WATERCOLORIST'S GUIDE TO
MIXING COLORS

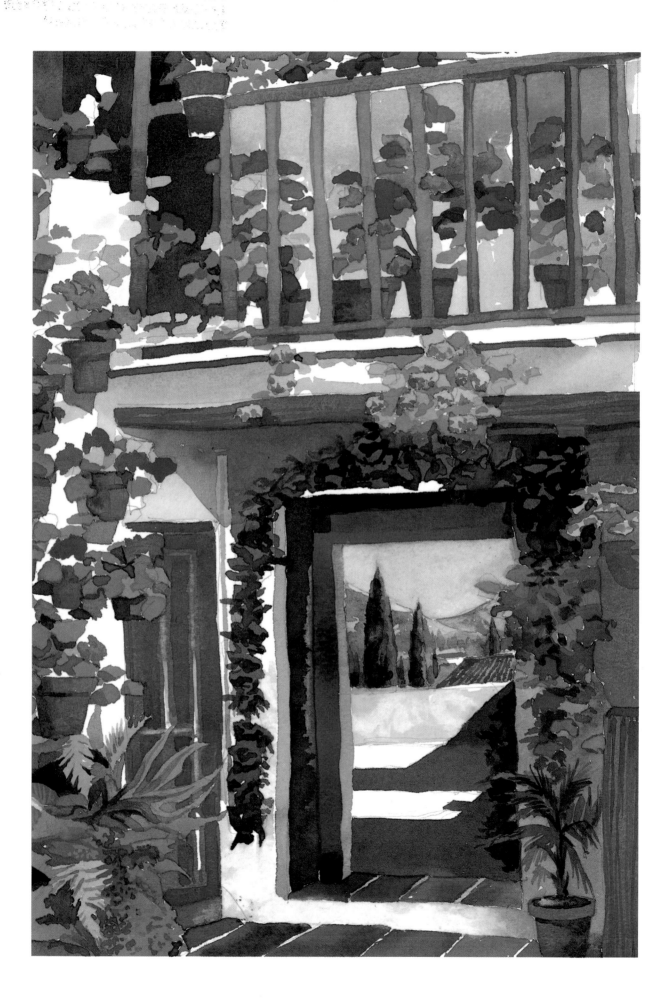

WATERCOLORIST'S GUIDE TO
MIXING COLORS

HOW TO GET THE MOST FROM YOUR PALETTE

Jenny Rodwell

Illustrations by Adrian Smith

NORTH LIGHT BOOKS

Cincinnati, Ohio

A DAVID & CHARLES BOOK

Copyright © Jenny Rodwell 1996, 1997

First published in North America
in 1997 by North Light Books,
an imprint of F&W Publications, Inc.
1507 Dana Avenue
Cincinnati, OH 45207
1-800/289-0963

ISBN 0-89134-797-6

Book design by Joe Short
and printed in Italy by New Interlitho SpA
for David & Charles
Brunel House Newton Abbot Devon

CONTENTS

INTRODUCTION

Take a little red, mix in a little blue, dab on a spot of yellow, work in a little more colour, keep adding more colours – and the result is mud.

Mud? Yes, unfortunately. With watercolour paints it is usually the case that the more colours you mix, the less colourful will be the end product. This characteristic causes beginners a lot of disappointment and it often bores children, putting some of them off for ever, after they have stabbed randomly and without guidance at their early paint sets.

It is rather like wanting to enjoy a musical instrument, or a game of football. The real enjoyment comes after you have begun to learn some basic rules and skills. If you don't know how to mix the colours you want, each one must be achieved by trial and error – a time-consuming procedure which usually produces overmixed, muddy results.

Learning to mix

Watercolour is the most popular of all painting mediums. The unique transparency of the paints and the beautiful translucent quality of the colours attract both professionals and amateurs, with more and more people being tempted to try their hand. Sadly, the tendency to overmix colour has resulted in many newcomers to the medium giving up almost before they have started.

Successful watercolour painting depends a great deal on being able to mix the colours you need. Experienced watercolour painters do this with a speed and ease which makes the process look almost casual, but their confidence comes from knowledge and practice. It is important to remember that successful colour mixing is systematic. Once you know the basic principles, however, it becomes simple and automatic.

Keep it simple

The secret lies in simplicity, in keeping colour mixing to an absolute minimum. Remember that the more colours there are in a mixture, the duller the mixed colour will be. A single colour used directly from the tube or pan can sometimes be all that is required, but more usually two colours are necessary for harmonious results. You must know which ones, however, and in what proportions to mix them. Successful watercolours are dependent upon uncomplicated mixing and clarity of colour.

Systematic mixing

This book sets out, quite simply, to provide a guide to mixing all the colours you might need in order to paint any chosen subject.

As a starting point, we take a standard, popular palette of 12 basic colours. We can then go on to introduce the 132 colours that can be mixed by combining any two colours on the popular palette. These are shown on easy-to-follow charts which will help the artist, firstly, to choose a colour, and then to mix to it. As far as possible, the mixtures are consistent and the two colours are combined in equal quantities. By varying the proportions of each colour, the range of mixtures is obviously increased considerably.

Eventually, most artists develop a preference for certain colours, discovering and then sticking to particular favourites. For some, the ideal palette is extremely minimal, containing just a handful of colours with which to create a broad range of

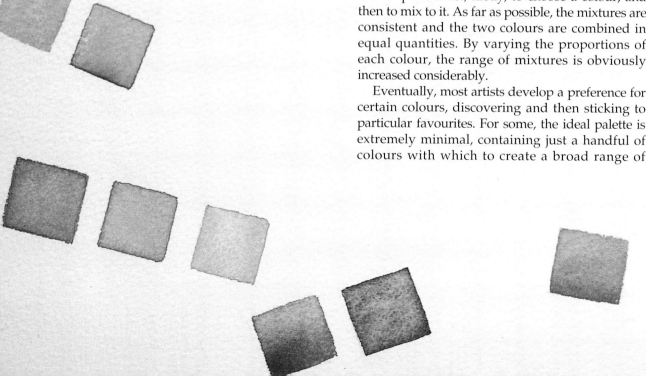

mixtures. Other painters keep mixing to an absolute minimum and for this reason prefer a wide and varied palette.

The 12 colours suggested here provide a starting point, a general-purpose palette which is used in many art colleges, but which can be changed to suit individual needs.

Special palettes

Choice of palette colours usually varies according to the subject. For example, the difference in brightness and colour between a northern European landscape and a landscape in the tropics or the Mediterranean is enormous. Artists who are used to working in one of these environments often find it very difficult to adjust to another. Usually, they discover that their normal palette is totally unsuitable for the new surroundings.

Similarly, a palette that captures the cold light of winter will not necessarily contain the colours needed to do justice to a hot day in summer.

This book makes practical suggestions for choosing colours to suit specific subject areas, with recipes for colour mixtures where appropriate. In some cases the changes are minimal, involving simply one or two alterations to the popular palette. Other subjects call for a more radical approach, with more fundamental changes.

Using this book

The book is essentially a practical guide. Colour theory is included only when it is relevant to 'hands-on' mixing, or when it provides some helpful background. Once familiar with the basic principles of mixing colour, it is hoped that the artist will then go on to develop a personal palette, and to experiment in all aspects of the medium.

If you wish, you can adopt a methodical approach to colour mixing by working through the various combinations, mixing and diluting colours until you are familiar with all the possibilities. On the other hand, the book is invaluable as a handy reference, a helpful guide to achieving particular colours as the needs arise in your painting.

The book assumes a basic knowledge of techniques and materials. Technique is discussed only in a few areas where the method has a different effect on the colour. For example, when creating whites and pale colours, certain techniques – such as the use of masking fluid, spattering and other texture-making methods – are directly concerned with the use of white and creating tonal effects. For this reason, relevant techniques are included where appropriate.

Straying from tradition

A purist tradition in watercolour painting discourages the use of white paint because it interferes with the transparency of the colours. This can certainly be true, especially in the hands of the inexperienced, when white paint is often introduced as a panic measure to lighten colours that have been applied too darkly, or to paint out mistakes. Clarity and brilliance of colour are easily lost, and a painting soon becomes irreversibly chalky and dead as a result.

However, there are occasions when white paint can be used effectively and to advantage, either to create areas of pale opacity, or to introduce texture.

The White and Black chapter provides an illustrated guide to the uses of white in watercolour. It also discusses the inclusion of black – another area of controversy – with advice on how to use black effectively without causing the colours to turn muddy.

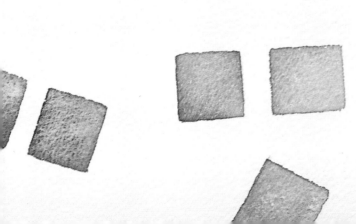

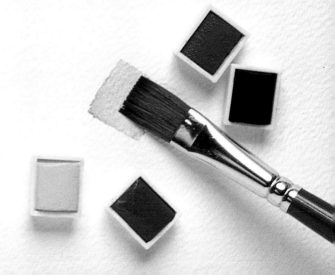

COLOUR

PIGMENTS

Every colour on the artist's palette comes from a pigment. To make watercolour paint, each pigment is ground to a very fine powder and then mixed with gum to bind the powdered particles, and glycerine to keep the paint moist.

The nature of the pigment determines the opacity or transparency of the paint, and how permanent the colour will be in the finished painting. Certain pigments, such as the cadmium colours, are extremely permanent and do not fade with time. Other pigments, like alizarin crimson and gamboge yellow, are only moderately permanent. Colours made from impermanent pigments are often described as 'fugitive'.

When mixing watercolours, some pigments are very strong and a little paint goes a long way. For example, Prussian blue and alizarin crimson are both powerful pigments with good 'tinting' or 'staining' capacity. Other pigments, such as manganese blue, have a weaker tinting strength and are less effective in colour mixtures.

Certain pigments are naturally more transparent than others. Transparent colours include alizarin crimson, gamboge yellow and French ultramarine. Transparent colours are useful for mixing glazes – thin layers of colour through which underlying colour is allowed to show. Opaque colours, like cerulean blue and Naples yellow, tend to cover and obliterate underlying colours and are not suitable for use as transparent glazes.

What are pigments?

At one time all pigments came from natural sources – either from animals and plants, or from the earth and rocks. Today, the range of colours is much wider because of the many additional pigments which have been developed in the laboratory and are now produced in factories.

Earth colours, including the ochres, umbers and siennas, are natural pigments obtained from clays and silicates dug up from the ground. The 'burnt' earth colours are made by burning or roasting the raw, excavated pigment in order to give it a reddish-brown colour.

Then and now

Many original pigments are now impractical or unobtainable and the colours have been replaced by modern equivalents.

For example, lapis lazuli, the brilliant blue used in many Renaissance paintings, is a rare mineral pigment, most of which came from an isolated region of Afghanistan. The price was always prohibitive, and for this reason the colour is now virtually obsolete. A close equivalent can be mixed from Winsor blue and white.

It became crucial to find substitutes for pigments which originally came from animals and insects. Alizarin crimson replaced a pigment known as carmine lake – a purplish red made by grinding up the dried bodies of an insect species which lives on the cacti of South and Central America. Cochineal

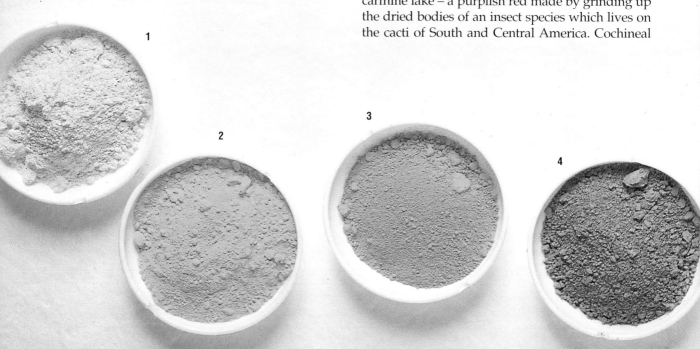

1

2

3

4

once came from the same unfortunate source.

Indian yellow was traditionally obtained from the dried urine of cows fed only on a diet of mango leaves. Less cruel and more accessible, modern Indian yellow is made chemically from synthetic iron oxide and diarylide yellow.

Sepia, once extracted from the ink of the common squid, has now been replaced by a modern dye. This is easily made and is more permanent than the original sepia, which faded in strong light.

Colour ranges are constantly changing for many reasons. Even now, a particular pigment may become unobtainable or too rare to make its manufacture worthwhile. Also, some pigments are poisonous and have been classified as toxic. They include the chrome range and cinnabar green, and for this reason these colours have been discontinued by many manufacturers.

The pigments
1 Lemon yellow
2 Cadmium yellow pale
3 Cadmium yellow
4 Yellow ochre
5 Raw umber
6 Burnt sienna
7 Cadmium red
8 Vermilion
9 Alizarin crimson
10 Winsor violet
11 Viridian
12 French ultramarine
13 Cerulean blue
14 Cobalt blue

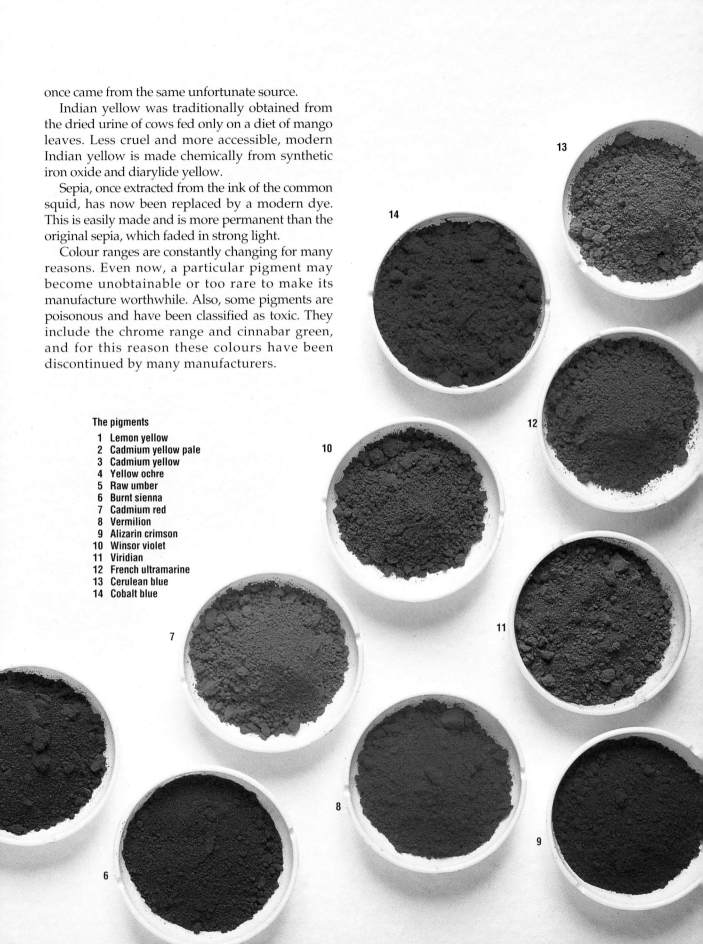

CHOOSING COLOURS

The 84 colours shown here are from the new Winsor and Newton watercolour range. Also available in the same range are titanium white, Chinese white, lamp black, ivory black, blue black, charcoal grey and neutral tint.

ARTISTS' WATERCOLOURS

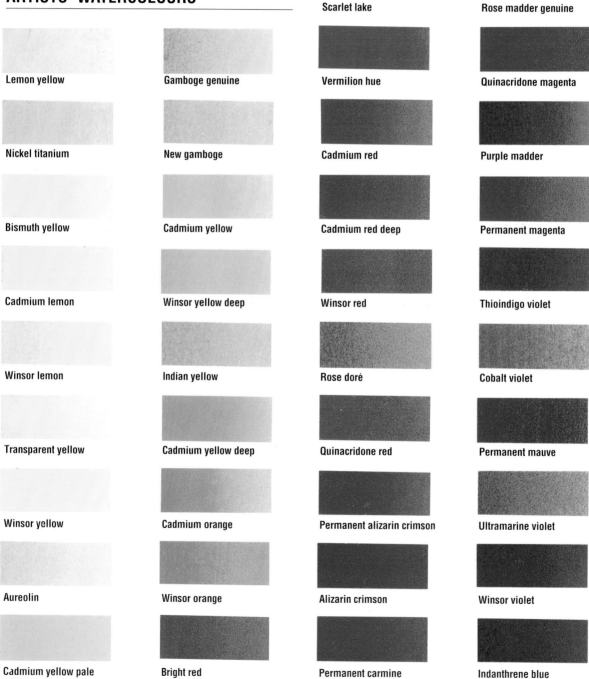

Lemon yellow

Gamboge genuine

Nickel titanium

New gamboge

Bismuth yellow

Cadmium yellow

Cadmium lemon

Winsor yellow deep

Winsor lemon

Indian yellow

Transparent yellow

Cadmium yellow deep

Winsor yellow

Cadmium orange

Aureolin

Winsor orange

Cadmium yellow pale

Bright red

Cadmium scarlet

Permanent rose

Scarlet lake

Rose madder genuine

Vermilion hue

Quinacridone magenta

Cadmium red

Purple madder

Cadmium red deep

Permanent magenta

Winsor red

Thioindigo violet

Rose doré

Cobalt violet

Quinacridone red

Permanent mauve

Permanent alizarin crimson

Ultramarine violet

Alizarin crimson

Winsor violet

Permanent carmine

Indanthrene blue

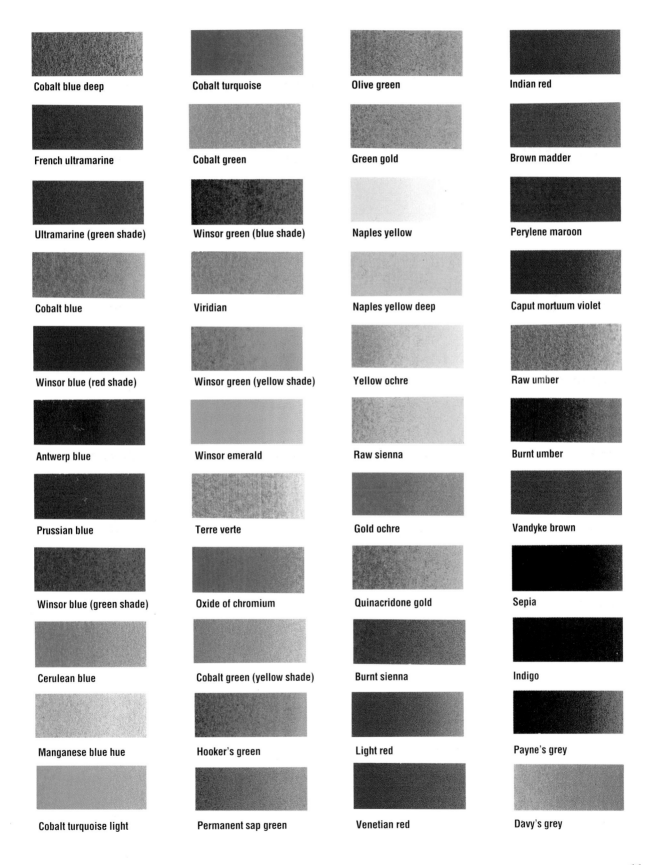

Cobalt blue deep	Cobalt turquoise	Olive green	Indian red
French ultramarine	Cobalt green	Green gold	Brown madder
Ultramarine (green shade)	Winsor green (blue shade)	Naples yellow	Perylene maroon
Cobalt blue	Viridian	Naples yellow deep	Caput mortuum violet
Winsor blue (red shade)	Winsor green (yellow shade)	Yellow ochre	Raw umber
Antwerp blue	Winsor emerald	Raw sienna	Burnt umber
Prussian blue	Terre verte	Gold ochre	Vandyke brown
Winsor blue (green shade)	Oxide of chromium	Quinacridone gold	Sepia
Cerulean blue	Cobalt green (yellow shade)	Burnt sienna	Indigo
Manganese blue hue	Hooker's green	Light red	Payne's grey
Cobalt turquoise light	Permanent sap green	Venetian red	Davy's grey

THE STORY OF COLOUR

So great is the availability of colours these days that modern painters are in danger of taking this for granted. It was not always so; yet the history of colour-making is one of steady improvement over the centuries. A twentieth-century artist need not know where pigments come from, or which ancient painter used which colour. Nevertheless, a knowledge of the past adds to a sense of perspective and gives the modern artist a place in history.

Our Stone Age ancestors created cave paintings using a handful of earth colours dug up from the ground. These included white chalk and a black which they collected from the soot of the fire. To this limited range of pigments they added animal fat, and the results of their work can still be seen today in France and Spain, some 15,000 years later.

Egyptian and Greek colours

By 4000 BC, Egyptian artists had added several bright colours to this earthy palette, notably vivid malachite green and azurite blue – mineral pigments made by crushing and washing the raw materials. They also had bright red in the form of cinnabar obtained from a Spanish rock, and orpiment yellow, a brilliant but highly poisonous pigment made from arsenic.

The Egyptians began to use vegetable dyes, and they also learned how to grind coloured glass to make pigment. This is how Alexandra blue, or blue frit, found its way on to the artist's palette.

To this considerable range, the Greeks added white and red lead; verdigris green, made by exposing copper to the fumes of fermenting grapes; and vermilion, a brilliant red which gradually replaced cinnabar.

The Renaissance

Many Renaissance colours are recognizable by their names. Costly lapis lazuli was still the coveted blue, but the Italian painters had an advanced knowledge of their own indigenous earth colours – the umbers, siennas and terre verte – the basis of most flesh colours. They also had Naples yellow and a more sophisticated range of the vegetable 'lake' colours used much earlier by the Egyptians.

Yellow and blue

The eighteenth century was a time for blues and yellows. Two natural yellows came into general use at this time – Indian yellow and gamboge, made from the resin of trees found in India, Sri Lanka and Thailand.

The first important blue was indigo, imported from the East at the beginning of the eighteenth century. The second was Prussian blue, discovered by accident when a German chemist, making medicine, spilled distilled animal oil on to a pile of potash. The contaminated potash was subsequently used by a colour-maker intending to produce a red 'lake', but the result was an unexpected deep blue – a blue which soon became popular as an affordable alternative to lapis lazuli.

The colours of industry

Many of the colours we use today are synthetic and have been developed and produced during the last 200 years. Some of these pigments are entirely new inventions; others are improved versions of much older colours.

Inevitably, so many discoveries develop into a list – a list which starts with the cobalt pigments, followed by ultramarine, a colour very similar to lapis lazuli and which was first discovered in the slag of soda furnaces.

Then came emerald green – unlike any other green, but highly toxic and unstable when combined with certain other pigments. Emerald green was a favourite of Van Gogh, who fortunately used it on its own, so the colour has survived, unimpaired.

In the 1830s, cheap and popular, came the 'chrome' colours in red, orange, green and yellow. Although chrome yellow replaced the highly poisonous orpiment yellow, it discolours when exposed to light. In addition, the chrome colours are themselves now classified as toxic.

From time to time, as methods of production improve, a new colour is introduced by a manufacturer. Occasionally an old one is dropped for reasons of safety, unavailability, or simply because it goes out of fashion.

A time chart showing the pigments available to artists up to the end of the nineteenth century. Phthalocyanine and quinacridone pigments, and many current colours, are twentieth-century products and are not illustrated here. A contemporary colour range is shown on pages 10–11.

ARTISTS' COLOUR THROUGH TIME

	STONE AGE	EGYPTIAN	GREEK	ITALIAN	18th–19th CENTURY
Red earth	███				
Yellow earth	███				
Carbon black	███				
Chalk					
Malachite		██			
Azurite		██			
Cinnabar		██			
Orpiment		██			
Egyptian blue frit		██			
Indigo		██			
Madder		██			
White lead					
Red lead			██████████████████████████████████		
Massicot			██████████████████████████████████		
Verdigris			██████████████████████████████████		
Vermilion			██████████████████████████████████		
Naples yellow				█████████████████████████	
Ground ultramarine				█████████████████████████	
Raw umber				█████████████████████████	
Burnt umber				█████████████████████████	
Raw sienna				█████████████████████████	
Terre verte				█████████████████████████	
Lead tin yellow				█████████████████████████	
Genuine ultramarine				█████████████████████████	
Prussian blue					███████████████
Gamboge					███████████████
Indian yellow					███████████████
Cobalt blue					███████████████
French ultramarine					███████████████
Emerald green					███████████████
Chrome yellow					███████████████
Lemon yellow					███████████████
Zinc yellow					███████████████
Oxide of chromium					███████████████
Viridian					███████████████
Cadmium yellow					███████████████
Mauve					███████████████
Cadmium red					███████████████
Zinc white					
Chinese white					
Cobalt green					███████████████
Cerulean blue					███████████████
Aureolin					███████████████

EARLY COLOURISTS

The prehistoric cave paintings of Altamira in northern Spain are so bright and well-preserved that when they were first discovered in the late nineteenth century many condemned the pictures as fakes. Few believed that primitive watercolours, made from pigment mixed with gum from trees or boiled bones, could last for 15,000 years. Nor would they believe that our palaeolithic ancestors could be such accomplished artists.

Since then, there have been other discoveries. In 1940, four French schoolboys playing in the Montignac region of the Dordogne came across similar pictures in the limestone caves of Lascaux. Nearby lay the artists' tools, including tubes of bone used for spraying fine colour.

Despite these astonishing beginnings, the development of watercolours has been surprisingly spasmodic and patchy. For centuries the medium was considered suitable only for illuminating manuscripts, painting miniatures and for making preliminary sketches for subsequent oil paintings.

The German artist Albrecht Durer (1471–1528) was probably the first European painter to treat watercolour as a serious alternative to oils. He used the transparent colours for tinting his woodcuts and engravings and for making detailed studies of flowers, plants and animals. Yet, after his death, watercolour again fell into obscurity, being generally considered a secondary medium to the more widely used oil paint.

Only comparatively recently, since the nineteenth century, has watercolour enjoyed consistent popularity, and it is now appreciated as a medium in its own right.

ALTAMIRA CAVE PAINTING

A painting of a bison found in the caves of Altamira, northern Spain. Available colours included carbon black, white chalk and earth pigments.

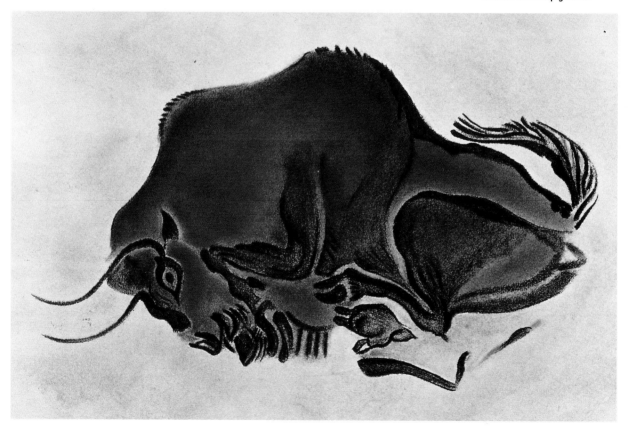

MADONNA AND CHILD by Albrecht Durer

The German artist was among
the first European painters to
use watercolour as a medium
in its own right.

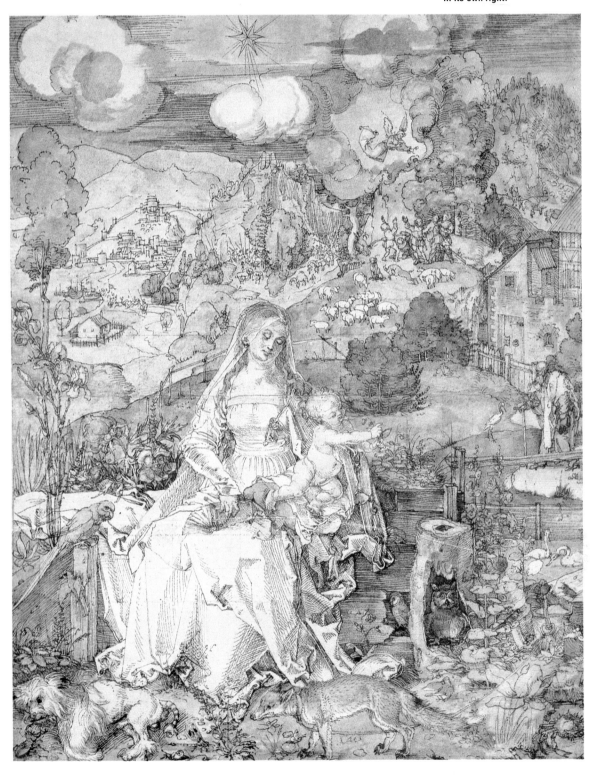

THEORIES AND IDEAS

The colour wheel with its familiar red, yellow and blue sections is now such a standard illustration of colour mixing that it seems as old as the colours themselves. In fact, however, the first primary colour wheel was not invented until 1776 when the Englishman Moses Harris found that colours would be more easily illustrated and explained if they were placed in a circle.

In the nineteenth century a French colourist, Michel Chevreul, developed a wheel bringing in the secondary and tertiary colours, which had a profound influence on many artists of the time.

Optical mixing

Chevreul's wheel, the basis of most contemporary colour theory, is the foundation of all colour

CLASSIC COLOUR WHEEL

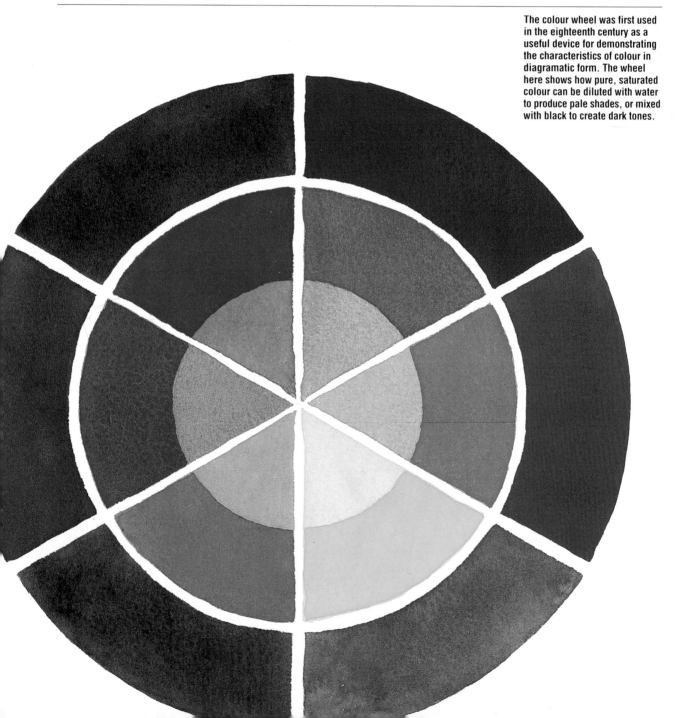

The colour wheel was first used in the eighteenth century as a useful device for demonstrating the characteristics of colour in diagramatic form. The wheel here shows how pure, saturated colour can be diluted with water to produce pale shades, or mixed with black to create dark tones.

teaching in art colleges today. It was of particular significance to the Impressionists and neo-Impressionists, who discovered from Chevreul's work that colours could be mixed optically, in the eye, rather than being premixed on the palette.

For example, instead of mixing orange from red and yellow, and thereby forfeiting some of the colour intensity, these artists began to apply dabs of pure red and yellow directly to the picture. In the eye of the viewer the two colours merged to produce a vivid, vibrant orange.

The neo-Impressionists, who developed optical mixing to a fine degree, were often referred to as 'pointillists' because of the way in which they applied the colour. Look at any painting by Signac, one of the main exponents of pointillism, and you will find little in the way of flat colour. Each colour is made from combinations of small coloured dots.

Colour from light

Instead of red, yellow and blue, many people think of a different set of primaries: red, blue and green. These 'additive' primaries, as they are called, are not really relevant to the painter, but they can cause confusion unless it is remembered that they refer to light rather than pigments.

The additive primaries result from light being passed through a prism. Red and green light projected together produce yellow; blue and red make magenta; and green and blue produce a bluish green known as cyan. With additive mixing, these secondary colours are always brighter than the primaries. When the three additive primaries are projected in equal quantities on to a white screen, they turn into white light.

Artists' primaries behave in an opposite way – as we know, the artist's secondary colours are duller than the primaries and the more colours we mix, the duller and darker they become. For this reason, artists' primaries are sometimes referred to as the 'subtractive' primaries.

Subtractive primaries
The subtractive or 'painter's' primaries are red, yellow and blue. Mixed in equal quantities, they produce a dark neutral.

OPTICAL MIXING

Dots of pure colour merge in the eye of the viewer to create the effect of a mixed colour.

Viridian and lemon yellow

Lemon yellow and cobalt blue

Winsor red and Winsor violet

Alizarin crimson and aureolin

Additive primaries
Red, green and blue are the additive or 'light' primaries. When projected in equal quantities, they make white.

THE PRIMARY PALETTE

Imagine you have been commissioned to create a painting of a dense bed or garden of flowers for an awkward eccentric who hates all colours except the simple primaries – red, yellow and blue. Judging by what we have said earlier, this would seem a sadly restrictive order. It need not be so. The three primaries have much to offer.

In fact, for those seeking to extend their practical knowledge of colour, this is a most useful commission. It will reveal that the primaries can be surprisingly flexible, and there is no more effective way of discovering the parameters of these three fundamental colours than to make a painting with them alone. In addition, by doing without the other, non-primary colours, the roles that these play will be more clearly exposed. When you come to choose a more extensive palette, you will have a much better idea of what the additions should be.

Knowing the boundaries

First, let us look at the limitations. As we have learned, the closest that pigments can come to the perfect primaries is with cadmium red, cadmium yellow and French ultramarine. We shall therefore have to work without black or white: we must find other ways of creating lights and darks. We also have to rule out vivid greens and violets, as these are unattainable with the pigment primaries alone.

No matter how we vary the mixtures between the three primaries, there will be a tendency to produce the same recurring colours. If you mix the primaries evenly, you will get a neutral. If you mix them so that one dominates, as with a bluish neutral, you might think at first that you are creating a different colour – but in the final work all the neutral mixes will look very similar.

Respecting the boundaries

The way to tackle the assignment is not to cheat the limitations by aiming for a host of different colours. If you try to achieve an approximation of many colours, you will end up floundering in mixtures that become increasingly muddy. An attempt to depict all the subtle shadow tones of the flowers and leaves in the subject below, for instance, would lead to such muddiness. A good rule of thumb is to restrict mixes to two primaries wherever possible.

Some watercolour artists apply new colours on top of underlying colours which are still wet. The effect of colours running into each other can be attractive, but beware: when restricted to primaries alone, the merging colours will tend to go muddy.

So let us capitalize on the situation, facing up to the fact that we cannot chase all the subtleties with mixes from our three primaries alone. Stick to pure colours and aim to simplify the subject, as the artist has done with the red and yellow flowers in the painting below. Here, the shadows on the petals and other parts of the flowers are indicated by using thicker colour, which gives a deeper tone.

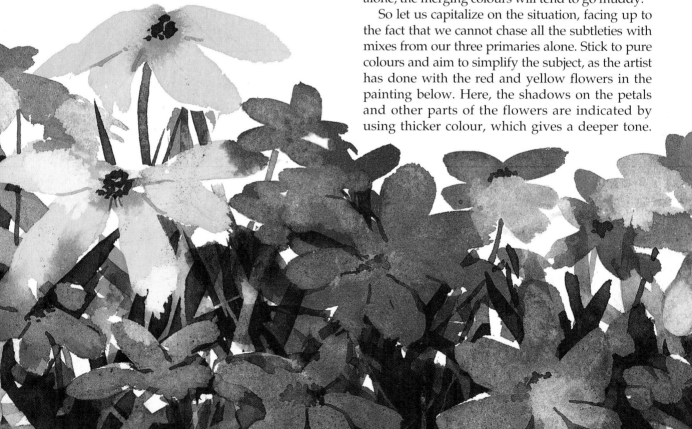

Where the light falls on the petals, the same pure, unmixed colour is used in a more diluted form.

Whites and lights

Without white, you cannot mix pink, pale yellow or pale blue. The answer is to dilute the colour with water. The more diluted the colour, the paler it becomes and the more white paper will show through, to give you pales and pastels. Remember that, as with white highlights, advance planning is necessary to retain the areas that will be left pale.

A sense of space has been given to the picture below by using very dilute colour on the distant foliage and flowers, making them appear to recede into the background.

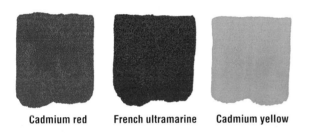

Cadmium red **French ultramarine** **Cadmium yellow**

Although green is restricted to a mixture of yellow and blue, variations in tone can be achieved by diluting with water and altering the ratio of blue to yellow. Cadmium yellow with a touch of blue, for instance, will give you a reasonably fresh, spring-like green. Sometimes a tiny touch of red will produce a warmer green, but this really means tiny – too much will again lead towards a neutral.

For whites, you can employ a major tradition of watercolour painting – leaving areas of the white paper unpainted. This means that you have to plan ahead. You will need to outline all the shapes which will be white, so that these areas can be left. To avoid painting over smaller shapes by accident, masking fluid can be used to protect the designated white areas from subsequent layers of colour.

In the picture below, note that the white flowers are depicted simply by the whiteness of the unpainted underlying paper.

Without black

There are some very dark spots in the painting below. In the areas between the leaves and stems we find deep shadows. How are these depicted without black? The answer here was to use blue mixed with a little red. By using very little water, the tone is kept dark enough to indicate deep shadow. Here we are making use of a limitation – the primaries blue and red fail to produce a bright violet or purple and the mixture dulls and darkens, which is exactly what we want in this case.

For a different subject, the same colours could have been mixed, but with a larger proportion of red, producing a brownish shadow.

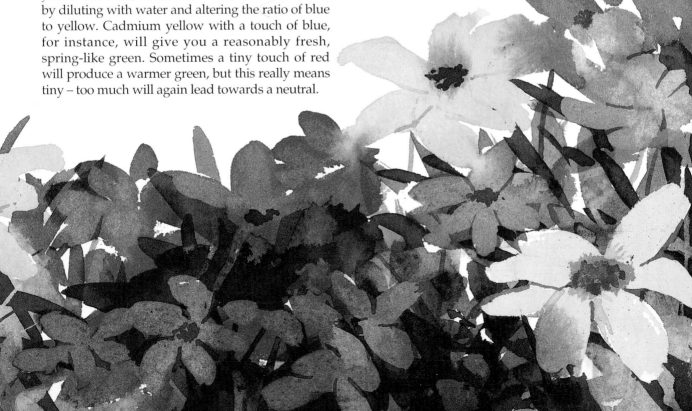

SECONDARY COLOURS

You will never see the brightest green if you rely on mixing it from primary colours. This is the case even though, as the painting on the previous page shows, much can be achieved using the primary colours alone. Orange can be mixed from red and yellow; green from blue and yellow; and violet from red and blue. These three – orange, violet and green – are known as the secondaries.

For the artist, there is one serious disadvantage to mixed primaries: the resulting secondaries are never as bright or intense as the primary colours which went into their making. The mixed secondaries are always darker and often duller. You will get adequate greens, oranges and violets, but never the brightest. For this you will need to buy other colours – colours which come from a single pigment source.

For instance, a bought green, such as viridian or emerald, is brighter than any green mixed from primary blue and yellow; cobalt violet or Winsor

violet are brighter than any mixture of primary red and blue; and cadmium orange is brighter than a combination of primary red and yellow.

Getting round the problem

There is another reason why the primary colours do not produce bright secondary colours, and this is to do with colour 'bias'. With the exception of the three primaries, all pure colours are biased towards the adjacent colour on the colour circle. As you can see from the classic colour wheel on page 16, those reds closest to the blue section have a bluish tinge, or bias. For example, alizarin crimson and magenta are bluer than scarlet, which lies closer to the yellow section and therefore has a yellow bias.

A true primary red has no bias because it is exactly half-way between blue and yellow on the colour wheel. For the artist, no pigment represents exactly a true primary, so we have to use close equivalents. These are usually considered to be

THE SECONDARIES

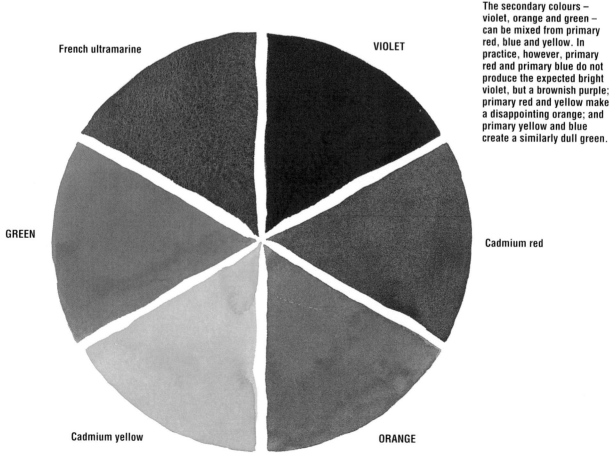

French ultramarine

VIOLET

GREEN

Cadmium red

Cadmium yellow

ORANGE

The secondary colours – violet, orange and green – can be mixed from primary red, blue and yellow. In practice, however, primary red and primary blue do not produce the expected bright violet, but a brownish purple; primary red and yellow make a disappointing orange; and primary yellow and blue create a similarly dull green.

French ultramarine blue, cadmium red and cadmium yellow, although some artists use cobalt as a preferred equivalent to primary blue. There is no perfect match; French ultramarine is slightly warm, with a red bias, and cobalt blue is colder, with a slightly yellow bias.

Practically, cadmium red does not make a good violet when mixed with either French ultramarine or cobalt blue. Nor does it make the most vibrant orange when mixed with cadmium yellow.

When mixing colours, the brightest achievable violet is mixed from a red which has a blue bias (such as alizarin crimson) and a blue which has a slightly red bias (such as French ultramarine).

Similarly, the most effective orange is mixed from red with a yellow bias and yellow with a red bias. The most vivid green is mixed from yellow with a blue bias, and a blue with a yellow bias.

This sounds complicated, but by following the 'practical' colour wheel below, which gives suggested alternatives to the three primaries, you will discover it is possible to mix brighter greens, violets and oranges than would be possible from the primary equivalents.

There is more about different ways of mixing greens, oranges and violets on pages 48–53.

PRACTICAL COLOUR WHEEL

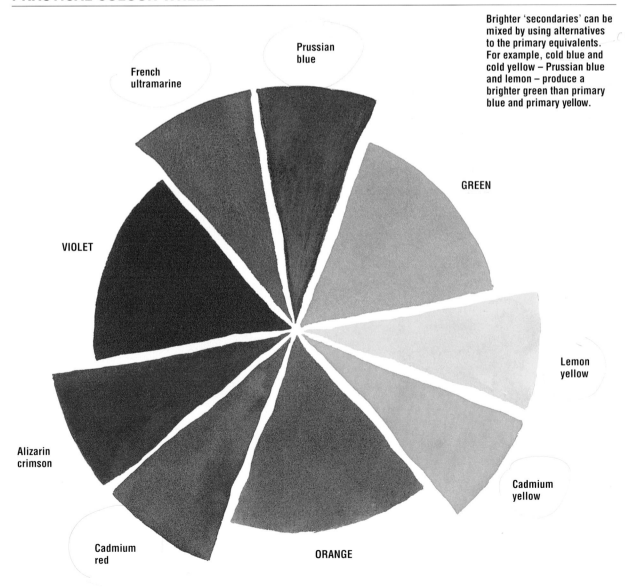

Brighter 'secondaries' can be mixed by using alternatives to the primary equivalents. For example, cold blue and cold yellow – Prussian blue and lemon – produce a brighter green than primary blue and primary yellow.

French ultramarine

Prussian blue

GREEN

VIOLET

Lemon yellow

Alizarin crimson

Cadmium yellow

Cadmium red

ORANGE

TERTIARY COLOURS

Very few artists stop to consider whether or not they are mixing a tertiary colour as they strive to find the right greenish yellow for a summer landscape, or clear greenish blue for the sea. Why should they? If they did, the painting process would soon become a pain rather than a pleasure. But to make the most of a limited palette, it is helpful to know the full range of possibilities.

The three primaries will give you a third set of colours known as tertiaries. A tertiary colour is simply a mixture of a primary colour with a secondary colour. Thus, blue with violet gives you a bluish violet, green with yellow gives a yellowish green, and so on.

With practice, colour mixing becomes instinctive, but it is only really successful if the painter is familiar with the full potential of the colours on the palette and knows what to expect when certain colours are mixed together.

Mixing tertiaries

From the previous page, we know the problems of light and colour loss when mixing secondaries from the true primaries. This dullness is even more apparent when we try to mix tertiaries from the pure primaries.

To keep the tertiary colours as bright as possible, start with the appropriate colours from the practical colour wheel on the previous page. For instance, when mixing yellowish green or greenish yellow, start with lemon yellow and cerulean blue rather than primary blue and yellow.

THE COLOURS

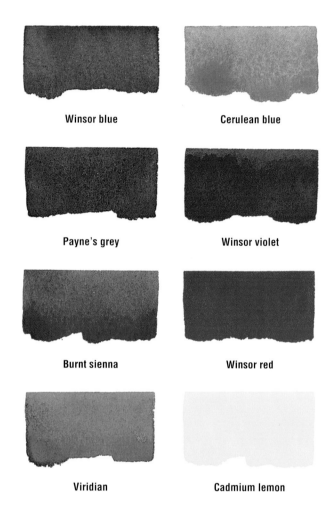

Winsor blue

Cerulean blue

Payne's grey

Winsor violet

Burnt sienna

Winsor red

Viridian

Cadmium lemon

TERTIARY MIXTURES

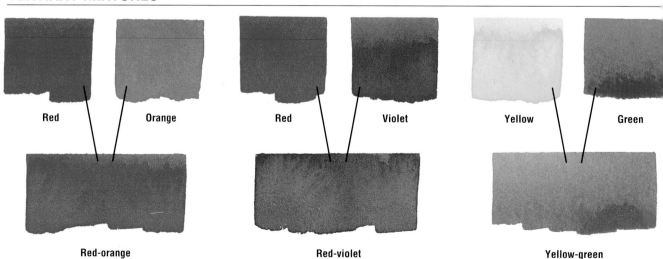

Red

Orange

Red

Violet

Yellow

Green

Red-orange

Red-violet

Yellow-green

LAKE ISLAND VILLAGE

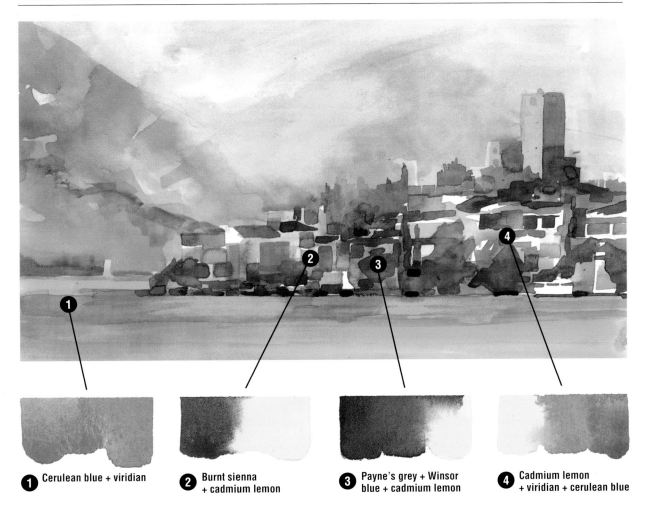

1 Cerulean blue + viridian

2 Burnt sienna + cadmium lemon

3 Payne's grey + Winsor blue + cadmium lemon

4 Cadmium lemon + viridian + cerulean blue

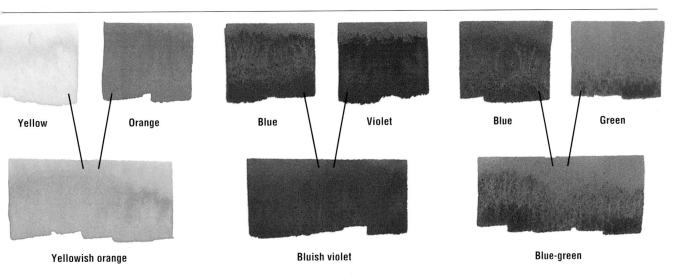

Yellow

Orange

Blue

Violet

Blue

Green

Yellowish orange

Bluish violet

Blue-green

OPPOSITES

Opposite colours have a curious effect on the human eye. If you stare hard at any shape of bright colour for a few minutes, then transfer your gaze to a white wall, you will see an after-image. This fades after a few seconds. During that time the eye sees the same shape, but perceives it in its opposite colour. This is because the receptors in the eye which have been looking at the first colour are tired, while the receptors that perceive the opposite colour are rested and react immediately.

Every colour on the colour wheel has an opposite, or complementary, colour. The obvious opposite colour pairs are red and green, blue and orange, and yellow and violet, but every other colour on the wheel also has an opposite. Take any tertiary colour, and its complementary can be found facing it on the other side of the wheel. Hence, the complementary of bluish violet is yellowish orange; the complementary of yellowish green is reddish violet; and so on.

In paintings, the use of opposites produces a similarly startling sensation, and artists have long made use of the visual properties of opposite colours. By laying a colour next to its opposite, the effect is to make both appear more vibrant than they would be if perceived separately.

However, when both colours are used in equal amounts, the effect can be counter-productive. The two colours compete and may even be uncomfortable to look at. Some artists deliberately set out to achieve this effect, but as a general rule, the result is more pleasing when a small amount of one colour is introduced to set off a more dominant area of its complementary.

It is surprising how many paintings are based on the use of opposites, and how effective the colours appear as a result. Simple instances can be seen in flower paintings, in which green foliage can make red flowers look extraordinarily bright, but an opposite colour theme is to be found in many other subjects. Often the artist has used more than one pair of colour opposites in the same picture.

COMPLEMENTARY PAIRS

Colours which lie opposite to each other on the colour wheel are complementary. Examples are red and green; blue and orange; and yellow and violet.

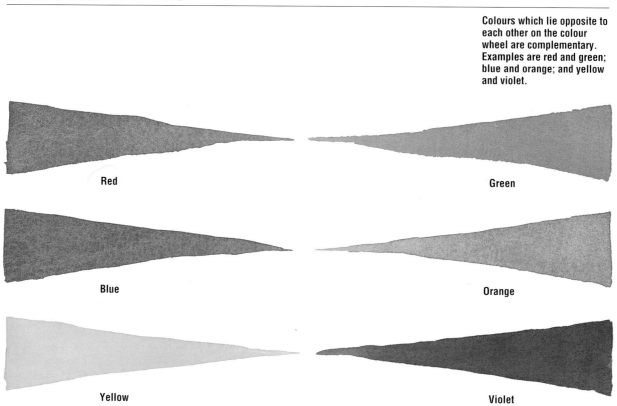

Red

Green

Blue

Orange

Yellow

Violet

WHEEL OF OPPOSITES

Colours on the wheel do not fall into convenient sections – they merge into a continuous spectrum. From this wheel it can be seen that the opposite of yellowish orange is bluish violet; the opposite of red with a touch of orange is green with a similarly small touch of blue; and so on.

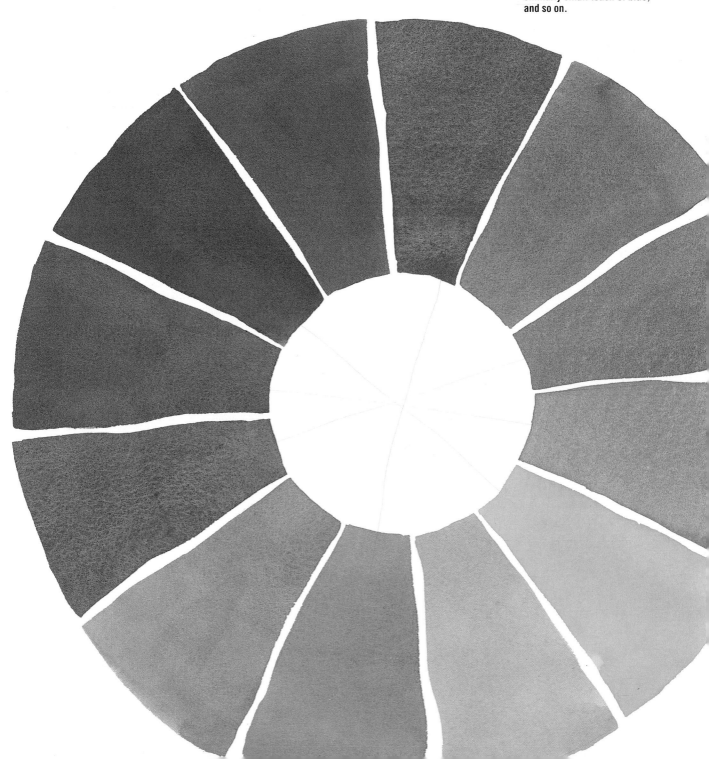

WARMS AND COOLS

TEMPERATURE

Colours which remind us of the sun, fire and desert sands are warm colours – the oranges, reds and yellows on one side of the colour wheel. On the other side of the wheel are cools – the blues and greens which are associated with chilly subjects such as ice, water, snow and wintery skies.

A painting done entirely in all-warm or all-cool colours not only looks boring, it also looks unconvincing – rather like a faulty colour print in which one of the colours has been accidently left out. This is because the world around us is made up of both warm and cool colours, and even those subjects which are obviously very cool or very warm contain contrasting colour temperatures within the main colours, although these may be so subtle that they are not immediately apparent.

Take an extreme example. A chilly snow scene may be all-white with a cold blue or grey sky and bare, skeletal trees, but within this cool composition there are inevitable warmer patches – colours which are warm in comparison with the rest.

Earthy shadows, light reflected on the tree trunks, winter light in the sky – all these elements are comparatively warm, and they contrast with the cool colours, making them appear even cooler. Ironically, a few warm touches can make a chilly scene even chillier.

Conversely, a still-life subject consisting only of warm oranges, reds and yellows always contains contrasting shadows and areas of cooler colour.

Cool warms and warm cools

Colour temperatures vary within the same named colour group. For example, although red is generally thought of as warm, some reds are much warmer than others. Those reds which contain a lot of blue appear quite cool when seen next to an orangey red. Similarly, lemon yellow is much cooler than cadmium and other golden yellows, while French ultramarine is warmer than most other blues, including cobalt, cerulean, indigo and Prussian blue.

SOME WARM COLOURS

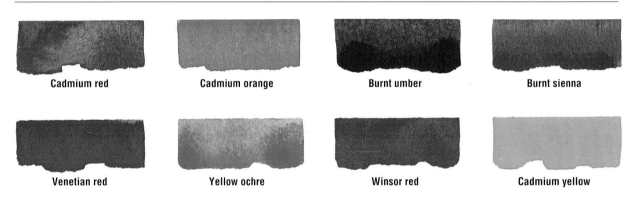

Cadmium red	Cadmium orange	Burnt umber	Burnt sienna
Venetian red	Yellow ochre	Winsor red	Cadmium yellow

SOME COOL COLOURS

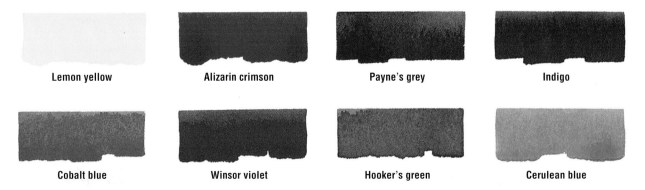

Lemon yellow	Alizarin crimson	Payne's grey	Indigo
Cobalt blue	Winsor violet	Hooker's green	Cerulean blue

ROSES AND GYPSOPHILA

A floral subject showing use of warms and cools – reds and pinks for the flowers, and cool blues and violets for the vase and shadows.

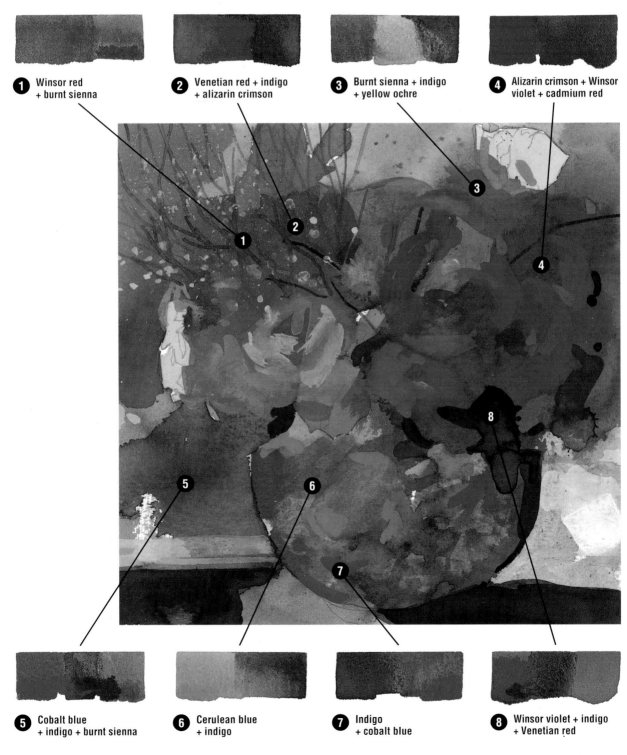

1 Winsor red + burnt sienna

2 Venetian red + indigo + alizarin crimson

3 Burnt sienna + indigo + yellow ochre

4 Alizarin crimson + Winsor violet + cadmium red

5 Cobalt blue + indigo + burnt sienna

6 Cerulean blue + indigo

7 Indigo + cobalt blue

8 Winsor violet + indigo + Venetian red

COMPLEMENTARY THEMES

Cool blues, violets and greens are brought to life whenever they are painted alongside their complementaries – warm oranges, yellows and reds. Similarly, the warm colours appear brighter and more effective when seen against their cool counterparts.

Complementary pairs occur naturally in most subjects and these can be exploited effectively by the artist. Even those subjects which contain no obvious complementaries usually display subtle traces of opposite colours. These traces can then be exaggerated and emphasized in order to enhance this characteristic.

In the landscape

Depending on the time of year, rural landscapes are predominantly green, golden or white, according to the season. But the local colours are never the only colours present in the landscape: for instance, green leaves, grass and trees all contain areas of comparative warmth which bring out the freshness and brightness of cool greens.

The painting below has patches of violet in the shadows. A hint of blue sky between the branches makes the bright autumn leaves even more vivid.

Manipulating the subject

When the subject is a still life, the artist has total control over its composition and by this means can determine the colour scheme of the eventual painting. When Shirley Trevena arranged the objects for the painting opposite, colour was uppermost in her mind.

Even before the painting started, the artist had established the picture as a study in opposite colours, carefully choosing objects of yellow, gold and orange to complement the cobalt, cerulean and French ultramarine blues and violets of the china.

NEW ENGLAND AUTUMN

In this autumnal scene reds, yellows and ochres contrast with patches of cool blue and violet.

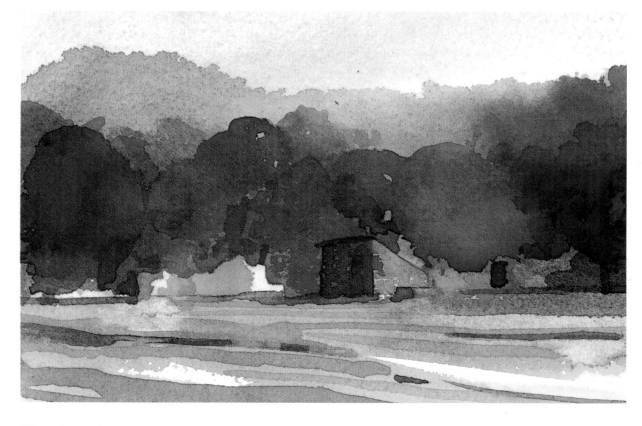

BLUE CHINA

For Shirley Trevena, a painting begins with the planning and arranging of the subject. Here she chose objects of gold and orange to complement the violets and blues of the china.

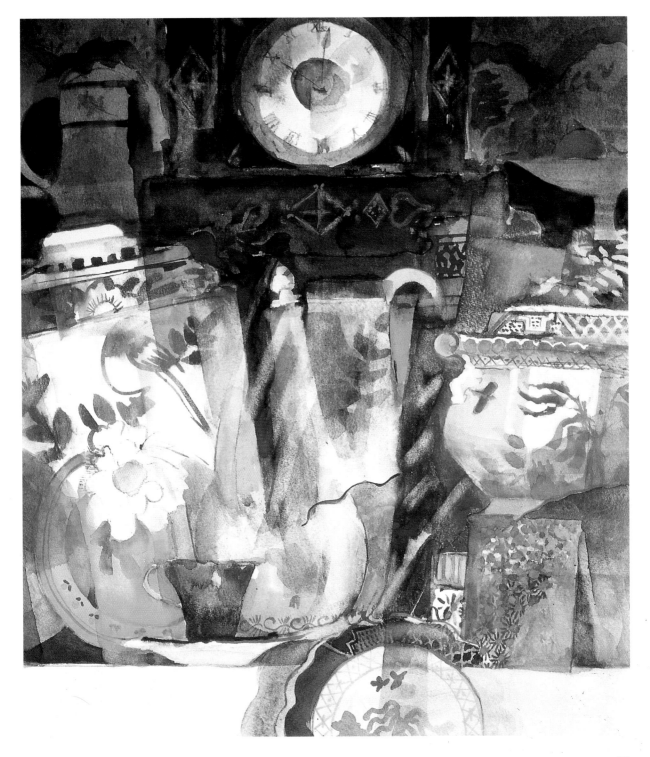

COLOUR REACTION

Humans often see what they 'know' to be there rather than what they are really looking at. Paint a leaf shape in a yellowish green, and most people will describe the colour as green. Use the same colour to paint a flower shape, and it is generally perceived as yellow. This is because we 'know' that a leaf is usually green, and that a flower is not.

Therefore, when learning about colours and the effects of colour on the eye, it is helpful temporarily to abandon the subject and all recognizable objects, and to concentrate on the colour alone. This way, the brain cannot jump to conclusions and the results are not influenced by preconceived ideas.

Advancing and receding colours

A bright or warm colour tends to jump forward, or advance, whereas a cool or dull colour appears to recede. This can be seen clearly in the abstract illustration opposite, but it also holds true when the same colours are used in a figurative or naturalistic painting.

For example, bright red has the most advancing effect of all colours. Used in a painting, red is often the colour which first catches the eye and appears to be closest to the foreground of the composition. Conversely, muted blues, greens and greys will always sink into the background.

Watercolours have the advantage of being strong or pale, depending on the amount of water added to the paint. For the watercolour painter, the advancing and receding properties of colours are especially useful and easily exploited. The more diluted the paint, the more a particular colour appears to recede into the picture. Thus a few broad strokes of washy blue or grey are often all that are needed to suggest distant sky or hills.

Clashing colours

Certain colour combinations are uncomfortable to look at. The worst culprits are bright green and bright red, but orange and greenish blue, pale violet or pink with lemon, and numerous other colour pairs can result in a vibrating, clashing sensation when put next to each other.

To produce such effects, colour must be dense and flat. Watercolour used transparently or with an irregular or broken surface does not produce the same startling results. In any case, clashing colour

CORAL REEF

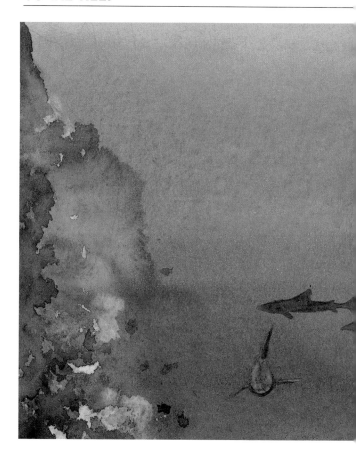

is not necessarily an effect to be avoided – many artists set out deliberately to create extreme optical sensations in their work, and their choice of conflicting colours is intentional.

Psychology of colour

Just as choice of colour is largely subjective and varies from person to person, so the response to a particular colour varies according to the individual.

For the artist, the psychological effect of a colour is not necessarily an important consideration: most painters are far more interested in the visual and aesthetic qualities of the colours they choose. Nevertheless, certain colours do affect the mood of a painting, and awareness of this can be helpful when creating a particular ambience or atmosphere. For example, most blues and greens are 'quiet' colours and evoke a feeling of tranquility, while oranges and reds are more imposing, seeming to demand attention.

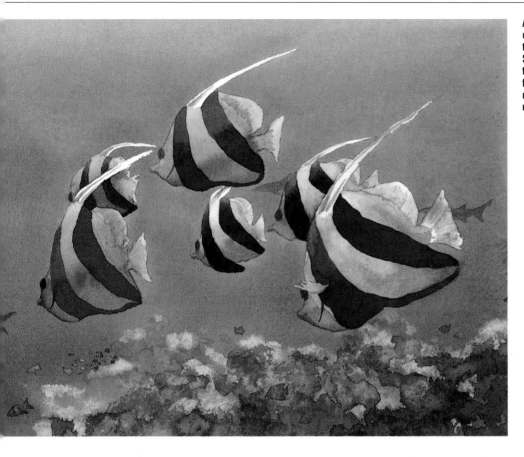

A simple and effective use of colour reaction enhances this underwater scene. Splashes of bright orange on the fins and tails make the foreground fish show up dramatically against the receding blue of the water.

WARM ON COOL

In this detail, the water and fish are seen as abstract shapes, not recognizable forms. However, the blue shape still appears to recede, while the orange shape advances.

COOL ON WARM

When colours are reversed, the illusion of deep water is destroyed. Here, the cool fish shapes appear to recede, while the bright orange 'sea' advances and stands out.

HARMONIES

If the colours in a painting do not have 'harmony', the result is like a musician playing a discordant or jarring note – whether by mistake, or because of a deliberate move by the composer to create discords as part of the overall musical effect.

To achieve colour harmony, it is important to know which colours 'go together' and how to mix them. It is also important to know when an exception is required.

Creating harmony

Fortunately, there are several ways of achieving a harmonious effect in a painting. A carefully limited palette is one solution. Another is to mix a little of a chosen colour with other colours in the composition, to produce a pleasing and integrated image. Alternatively, by working mainly with colours from the same section of the colour wheel you will automatically create a harmonious effect.

Analogous colours

Colours which are adjacent on the colour wheel and which have a primary colour in common produce what is sometimes referred to as 'analogous' harmony. Such colour groups occur naturally in many subjects. A rural landscape which includes a range of greens and a blue sky is a ready-made example of analogous harmony, because the main colours are from one section of the colour wheel. A still-life arrangement consisting of objects which are mainly red and orange is another example, but in this case the effect is contrived, with the artist deliberately choosing and arranging the subject in a harmonious way.

THE BLUE-GREEN SECTION OF THE COLOUR WHEEL

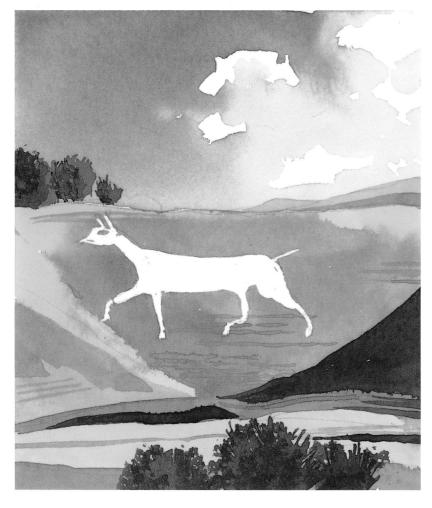

Green fields and a blue sky are a natural example of analogous harmony. The main colours in this illustration are taken from the section of the colour wheel which contains primary blue and greens.

A warning: a group of analogous colours can look monotonous if they are the only colours used in a painting, and a splash of a contrasting colour can work wonders in brightening up what is otherwise almost monochromatic theme.

Famous examples of this can be found among Van Gogh's sunflower paintings, in which the vase, flowers and background may be painted in colours almost entirely from the yellow and orange colour group – but green leaves or a touch of blue on a vase or background are inevitably used to bring the yellows and oranges to life.

Limited colours

Harmony can be created simply by restricting the number of colours on the palette. This device is especially useful to the newcomer to colour mixing, because it eliminates potential damage done by random dabbing. It also removes the temptation to use too many colours in the same painting.

With very few exceptions, most of the illustrations in this book are painted by artists using a palette of 12 colours or less. On pages 18–19 is an example of what can be achieved using the three primaries alone; for the beginner, there is

much to be learned from even greater self-denial – that of doing a painting using two colours alone.

Two-colour harmony

A scale of harmonious colours can be built up by gradually adding quantities of one colour to a second colour to create a range of colours. When two complementaries, such as red and green, are mixed together in equal quantities, the result is a neutral – not a true colour. When the starting colours are two primaries, an equal mixture of the two produces a secondary colour.

The harmonious scale has practical applications. As you can see from the painting on the following page, two appropriate colours can be surprisingly versatile. Not only do they produce a range of harmonious colours, but each colour can also be used densely or diluted, to create both dark and light versions of each mixture.

With practice, a harmonious painting can be achieved using a basic two-colour theme to which other colours are added selectively. With care, an image can contain a surprising number of colours without upsetting the harmonious balance established by the two main colours.

THE RED-ORANGE SECTION OF THE COLOUR WHEEL

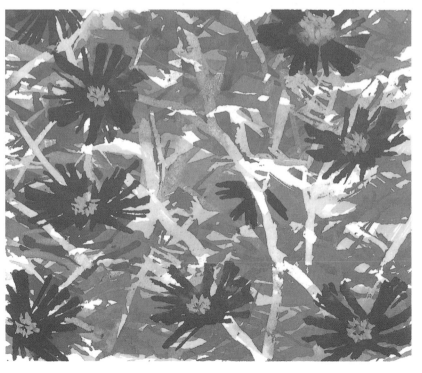

A mass of marigolds is painted in reds and oranges taken from the section of the colour wheel containing primary red and oranges.

USING TWO COLOURS

Two colours, carefully chosen to suit the subject, can sometimes be more effective than a whole palette full of colours.

Selection of colours is personal and depends very much on the subject, but a cool blue combined with a warm, earthy red is a classical choice and provides maximum mixing scope. Favourite combinations are Prussian, cobalt or cerulean blue used with either Indian red, burnt umber or burnt sienna. Each pair produces a subtly different range of harmonious colours. For the rocky seascape opposite, the artist selected Prussian blue and burnt sienna, to give an extended range of browns, greys and greens.

Sometimes, the addition of black to two colours provides not only an additional repertoire of dark tones, but also gives numerous neutrals and greys. However, because both Prussian blue and burnt sienna are dark in tone, the artist did not feel it necessary to use black in this painting.

BURNT SIENNA AND PRUSSIAN BLUE

A range of greys, browns and brownish greys can be achieved by mixing varying proportions of burnt sienna and Prussian blue. Mixtures range from dark and undiluted (top) to increasingly pale, diluted colours (bottom).

Burnt sienna Prussian blue

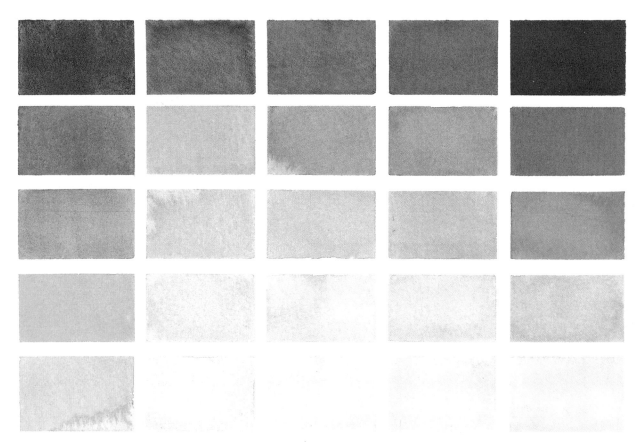

COVE IN DONEGAL

A watercolour sketch painted in just two colours – burnt sienna and Prussian blue.

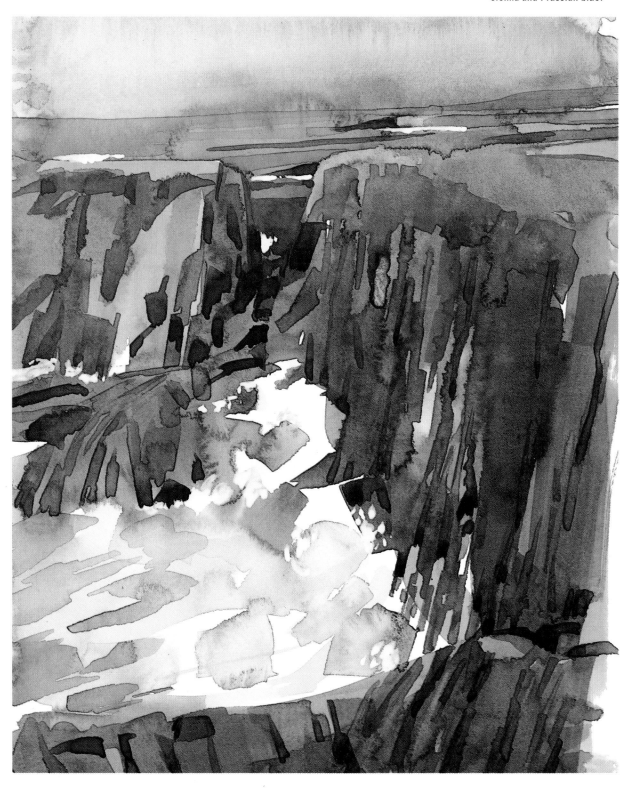

PERSPECTIVE WITH COLOUR

The traditional job of an artist is to create the illusion of three-dimensional form and also of space, and to do all this on a flat surface. Up to a point, this illusion is created automatically – not least because the subject of most paintings is familiar and therefore recognizable. Everyone knows that a teapot is round, that a road or railway line appears to taper off towards the horizon, and that trees in the distance look smaller than those in the foreground.

Atmospheric perspective

Nevertheless, many paintings which should look spacious and three-dimensional turn out looking disappointingly flat. Often this is simply because the artist has overlooked the properties of the colours themselves.

In landscape and seascape subjects, both of which often include a view into the distance, it is particularly important to remember that dull and cool colours recede and warm and bright colours advance. Distant colours are affected by the intervening layers of atmosphere, which cause colours to appear hazy or dull. This natural occurrence, sometimes called atmospheric or aerial perspective, is the reason why hills and mountains look progressively paler and bluer as they recede into the distance, and why objects seen from afar look hazier than similar objects viewed at close quarters.

A boat on a distant borizon may be bright red and a faraway tree may be bright green, but to ignore the effects of atmospheric perspective and paint such objects in their local colours will destroy instantly any illusion of distance and make the whole painting look flat and naïve.

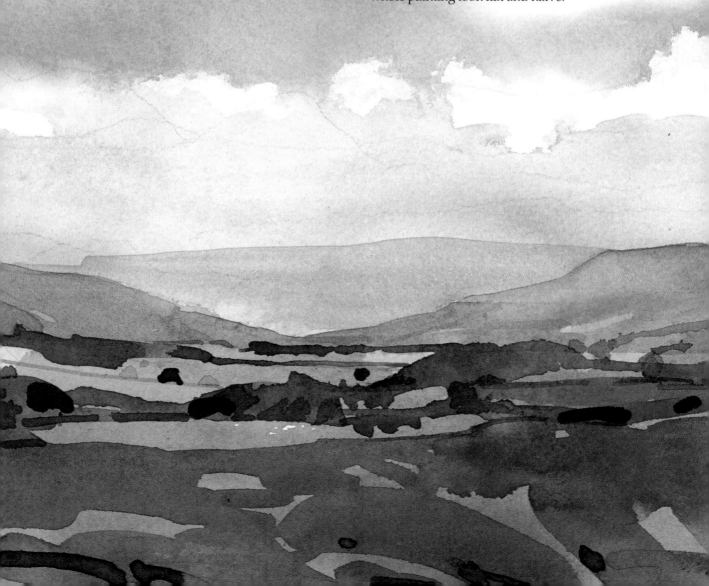

Fortunately, the transparent nature of watercolour paints make them well suited to coping with the fading effects of distance. Not only can colours be toned down by mixing each one with a little opposite or neutral colour, but the paint itself can be diluted to give faraway objects a pale, indistinct appearance.

Towards abstraction

When we look at a figurative painting – a picture with a recognizable subject – we are immediately concerned with the content of the picture. For example, a painted landscape invites us to look at the place portrayed in the picture. We notice the sky, the trees and buildings, the hills, and so on.

On the other hand, an abstract painting – a composition with no recognizable subject – forces us to look at other things. In some ways, this makes it easier to see the various elements which make up the painting, including the colours.

Much abstract art is concerned with the properties of pure colour applied to a flat surface. Often, the artists are simply applying the principle of colour perspective to an abstract arrangement of colours, creating visual sensations by arranging areas of colour in such a way that some recede while others jump forward.

Exciting visual contradictions are created in this way. For example, when a patch of cool, light colour is painted over a hot colour, the viewer instantly receives conflicting messages. Visually, the hot colour jumps forward. Yet logically, the cool colour must be in front of the hot colour, because it has obviously been painted on top of it.

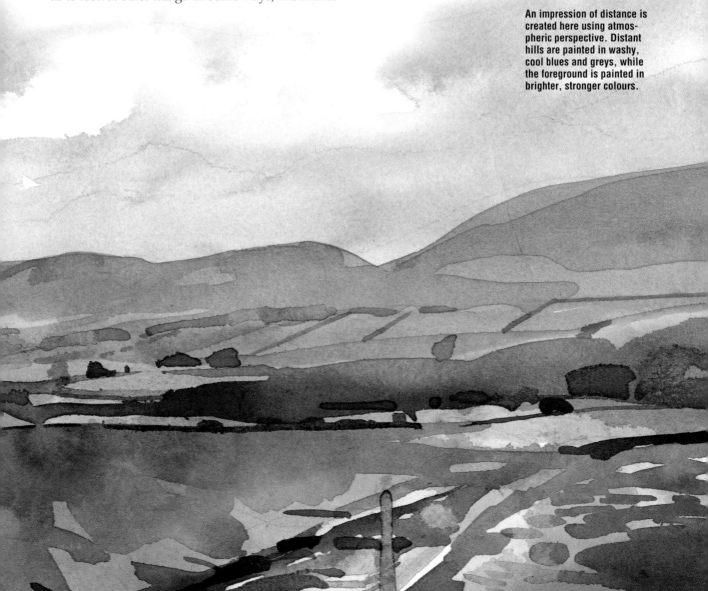

An impression of distance is created here using atmospheric perspective. Distant hills are painted in washy, cool blues and greys, while the foreground is painted in brighter, stronger colours.

MIXING COLOUR

THE POPULAR PALETTE

You can make 132 colours simply by mixing any two of the 12 colours on the palette which we recommend here as a starting point. This shows how versatile a simple basic palette can be.

For most work, certain colours are essential, even though there is no such thing as a standard palette and no single set of colours will give you everything you need for all subjects.

The 12 colours shown here form a general, popular palette: a suitable starting point for most subjects. There are omissions, but a little mixing will achieve most of the colours you might need. For example, Payne's grey – considered essential by many artists – is not on the list. It can be made from black and French ultramarine. The palette has only one green, but enough yellows and blues to provide a range of natural greens.

The only way to discover what effects you get when two or more colours are mixed together is to work through all the available colours. With experience, this becomes instinctive, and you will have a good idea in advance of which colours to use for specific results.

How the mixing works

On the following pages we show what happens when each colour on the basic palette is mixed with every other colour. The first colour in each panel is the basic one – shown against the results of its mixture with each of the others.

As far as possible, the colours are mixed in equal proportions. If you change the ratio of the two main colours, the result will have a bias towards one or other of these two main colours.

The possible permutations are extensive, but the charts might save you the trouble of going through 132 possibilities. Even so, they should never replace your own process of trial and error.

THE COLOURS

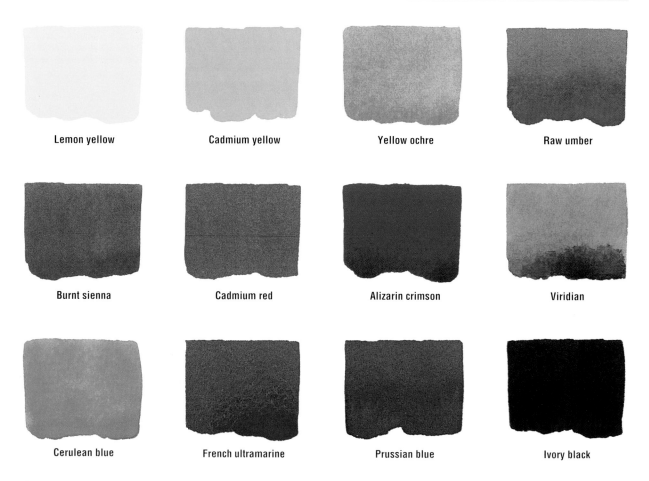

Lemon yellow Cadmium yellow Yellow ochre Raw umber

Burnt sienna Cadmium red Alizarin crimson Viridian

Cerulean blue French ultramarine Prussian blue Ivory black

SUMMER STILL LIFE

All the colours used in this painting are taken from the popular palette illustrated on the opposite page.

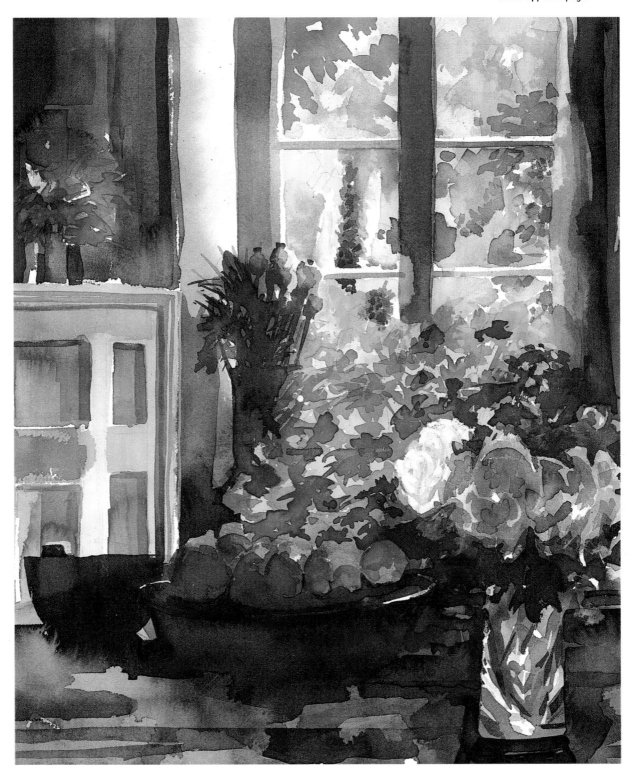

POPULAR PALETTE MIXES/1

LEMON YELLOW

LEMON YELLOW

+ Cadmium yellow

+ Yellow ochre

+ Raw umber

LEMON YELLOW mixed in equal quantities with each of the other colours on the popular palette.

+ Burnt sienna

+ Cadmium red

+ Alizarin crimson

+ Viridian

+ Cerulean blue

+ French ultramarine

+ Prussian blue

+ Ivory black

CADMIUM YELLOW

CADMIUM YELLOW

+ Lemon yellow

+ Yellow ochre

+ Raw umber

CADMIUM YELLOW mixed in equal quantities with each of the other colours on the popular palette.

+ Burnt sienna

+ Cadmium red

+ Alizarin crimson

+ Viridian

+ Cerulean blue

+ French ultramarine

+ Prussian blue

+ Ivory black

YELLOW OCHRE

YELLOW OCHRE

+ Lemon yellow

+ Cadmium yellow

+ Raw umber

YELLOW OCHRE mixed in equal quantities with each of the other colours on the popular palette.

+ Burnt sienna

+ Cadmium red

+ Alizarin crimson

+ Viridian

+ Cerulean blue

+ French ultramarine

+ Prussian blue

+ Ivory black

RAW UMBER

RAW UMBER

+ Lemon yellow

+ Cadmium yellow

+ Yellow ochre

RAW UMBER mixed in equal quantities with each of the other colours on the popular palette.

+ Burnt sienna

+ Cadmium red

+ Alizarin crimson

+ Viridian

+ Cerulean blue

+ French ultramarine

+ Prussian blue

+ Ivory black

POPULAR PALETTE MIXES/2

BURNT SIENNA

BURNT SIENNA

+ Lemon yellow

+ Cadmium yellow

+ Yellow ochre

BURNT SIENNA mixed in equal quantities with each of the other colours on the popular palette.

+ Raw umber

+ Cadmium red

+ Alizarin crimson

+ Viridian

+ Cerulean blue

+ French ultramarine

+ Prussian blue

+ Ivory black

CADMIUM RED

CADMIUM RED

+ Lemon yellow

+ Cadmium yellow

+ Yellow ochre

CADMIUM RED mixed in equal quantities with each of the other colours on the popular palette.

+ Raw umber

+ Burnt sienna

+ Alizarin crimson

+ Viridian

+ Cerulean blue

+ French ultramarine

+ Prussian blue

+ Ivory black

42

ALIZARIN CRIMSON

ALIZARIN CRIMSON

+ Lemon yellow

+ Cadmium yellow

+ Yellow ochre

ALIZARIN CRIMSON mixed in equal quantities with each of the other colours on the popular palette.

+ Raw umber

+ Burnt sienna

+ Cadmium red

+ Viridian

+ Cerulean blue

+ French ultramarine

+ Prussian blue

+ Ivory black

VIRIDIAN GREEN

VIRIDIAN

+ Lemon yellow

+ Cadmium yellow

+ Yellow ochre

VIRIDIAN mixed in equal quantities with each of the other colours on the popular palette.

+ Raw umber

+ Burnt sienna

+ Cadmium red

+ Alizarin crimson

+ Cerulean blue

+ French ultramarine

+ Prussian blue

+ Ivory black

POPULAR PALETTE MIXES/3

CERULEAN BLUE

CERULEAN BLUE

+ Lemon yellow

+ Cadmium yellow

+ Yellow ochre

CERULEAN BLUE mixed in equal quantities with each of the other colours on the popular palette.

+ Raw umber

+ Burnt sienna

+ Cadmium red

+ Alizarin crimson

+ Viridian

+ French ultramarine

+ Prussian blue

+ Ivory black

FRENCH ULTRAMARINE

FRENCH ULTRAMARINE

+ Lemon yellow

+ Cadmium yellow

+ Yellow ochre

FRENCH ULTRAMARINE mixed in equal quantities with each of the other colours on the popular palette.

+ Raw umber

+ Burnt sienna

+ Cadmium red

+ Alizarin crimson

+ Viridian

+ Cerulean blue

+ Prussian blue

+ Ivory black

PRUSSIAN BLUE

| PRUSSIAN BLUE | + Lemon yellow | + Cadmium yellow | + Yellow ochre |

PRUSSIAN BLUE mixed in equal quantities with each of the other colours on the popular palette.

| + Raw umber | + Burnt sienna | + Cadmium red | + Alizarin crimson |

| + Viridian | + Cerulean blue | + French ultramarine | + Ivory black |

IVORY BLACK

| IVORY BLACK | + Lemon yellow | + Cadmium yellow | + Yellow ochre |

IVORY BLACK mixed in equal quantities with each of the other colours on the popular palette.

| + Raw umber | + Burnt sienna | + Cadmium red | + Alizarin crimson |

| + Viridian | + Cerulean blue | + French ultramarine | + Prussian blue |

OVERPAINTING

When one colour is painted over another, the underlying colour affects the final result. Each of these panels is painted with a colour from the popular palette. Each painted panel was allowed to dry, and each of the other colours was then painted over the dry colour.

The effectiveness of overpainted colour depends largely on the colours used and how diluted these are. Dark colours will almost obliterate underlying colour, while lighter colours may be barely visible on a dark underpainting. We have tried to be consistent with the dilution of each colour.

OVERPAINTED COLOURS

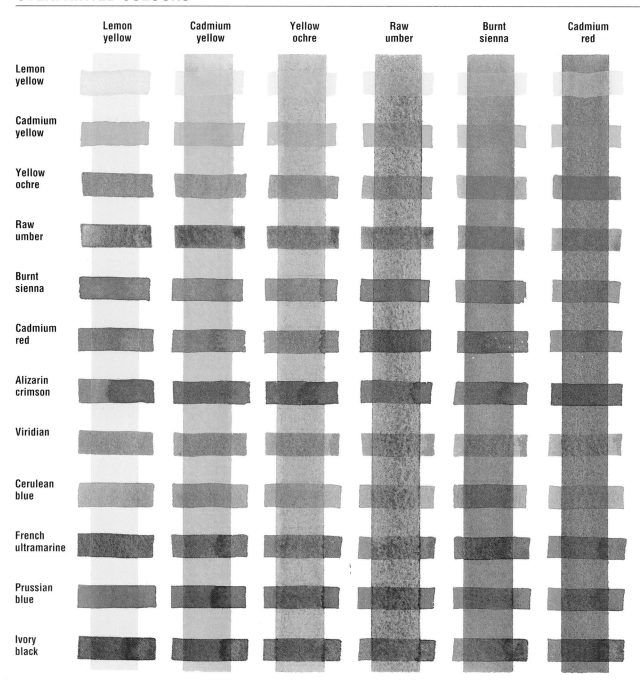

	Lemon yellow	Cadmium yellow	Yellow ochre	Raw umber	Burnt sienna	Cadmium red
Lemon yellow						
Cadmium yellow						
Yellow ochre						
Raw umber						
Burnt sienna						
Cadmium red						
Alizarin crimson						
Viridian						
Cerulean blue						
French ultramarine						
Prussian blue						
Ivory black						

Overpainted colours from the popular palette. In each case, the underlying colour was allowed to dry before a second colour was applied. The effectiveness of overlaid colour depends on the strength and transparency of individual pigments. Overlaid colours are painted in horizontal strokes.

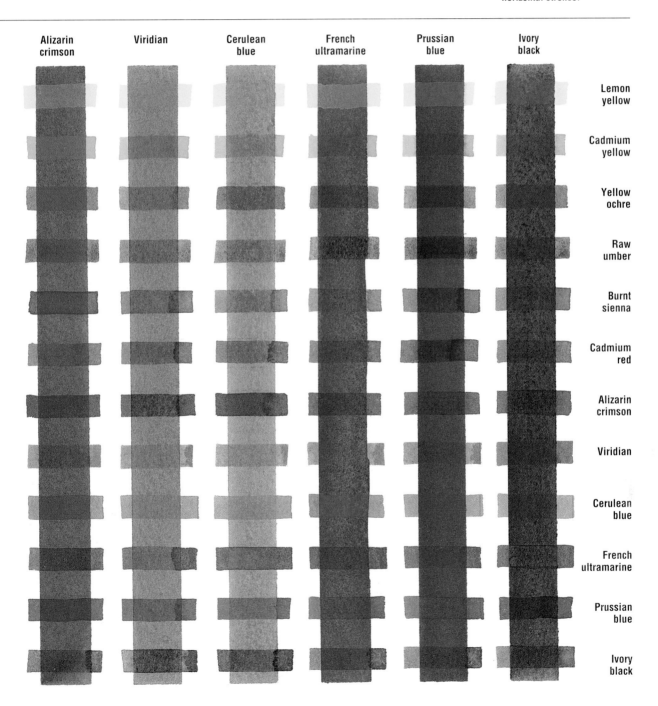

Alizarin crimson	Viridian	Cerulean blue	French ultramarine	Prussian blue	Ivory black	
						Lemon yellow
						Cadmium yellow
						Yellow ochre
						Raw umber
						Burnt sienna
						Cadmium red
						Alizarin crimson
						Viridian
						Cerulean blue
						French ultramarine
						Prussian blue
						Ivory black

PRACTICAL GREENS

Yellow and blue make green – but that is certainly not the end of the story. Green is probably the most used colour in the history of art, crucial to nearly all landscapes, but equally important when painting flowers, water, figures and almost every other subject.

Green is also the colour which presents the most problems, particularly to beginners. The difficulty usually stems from preconceived ideas held since childhood that grass, trees and all leaves are bright green, and must be painted as such.

A leafy landscape is obviously green, but the greens vary enormously, often with traces of silvery grey, ochres, browns, oranges and pinks. Shadows in grass and trees contain cool violets and dark greys. It is better to exaggerate these observed differences than to ignore them.

Always mix

The greens of nature are harmonious and varied. Unmixed greens can be difficult to integrate and should be used with care. For example, viridian is strong and transparent and is excellent in green mixtures. However, it can be intrusive when used on its own because it tends to dominate other colours, particularly in landscape paintings.

The colour mixtures on these pages show just how varied greens can be. Simple two-colour experiments with possible combinations of the available blues and yellows alone produces a formidable selection. To these mixtures can be added touches of red, black or earth colours to extend the range even further.

1 Cerulean blue + Chinese white + lemon yellow

2 Cadmium yellow + French ultramarine

THE BANANA GROVE

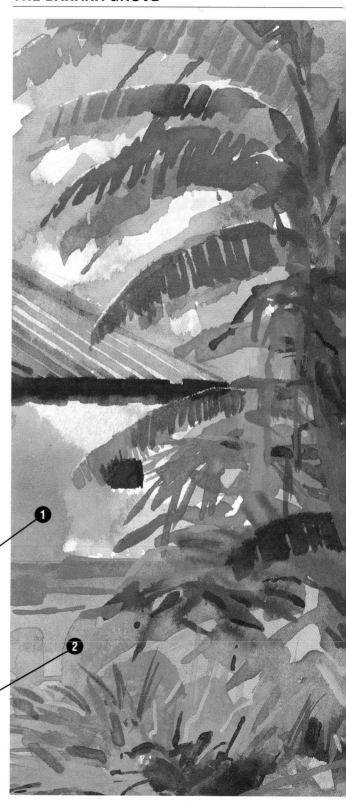

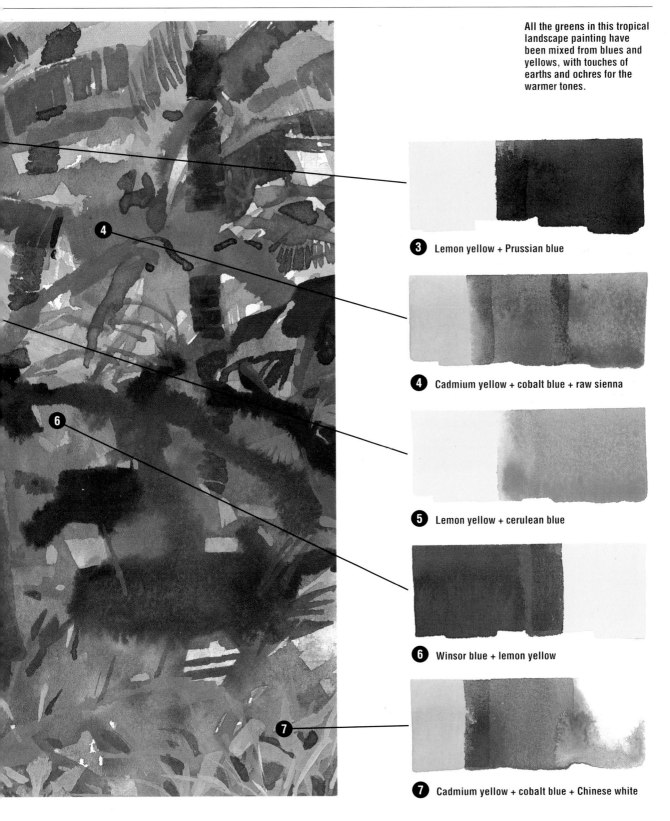

All the greens in this tropical landscape painting have been mixed from blues and yellows, with touches of earths and ochres for the warmer tones.

3 Lemon yellow + Prussian blue

4 Cadmium yellow + cobalt blue + raw sienna

5 Lemon yellow + cerulean blue

6 Winsor blue + lemon yellow

7 Cadmium yellow + cobalt blue + Chinese white

49

PRACTICAL VIOLETS

From the secondary and practical colour wheels on pages 20–21, it can be seen that blue and red produce violet, and that the brightest violet is the result of mixing a cold red with a warm blue.

However, as most reds and blues produce brownish purple when mixed instead of the expected violet, it is not easy to produce a wide range of good violets and purples by mixing alone. For this reason, a bought alternative such as cobalt violet is to be found on many palettes.

Cool shadows

The widest use of violets by the artist is in the painting of shadows and cool, shaded areas.

The colour of a thrown shadow or the shaded areas of an object or coloured surface is affected by the colour of the light which caused the shadow. As most light sources – including the summer sun and electric bulbs – are warm and yellow in colour, the resulting shadows inevitably contain a certain amount of complementary cool violet.

THE BODHRAN PLAYER

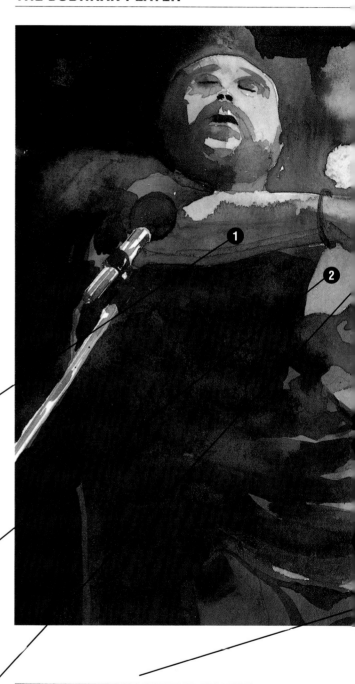

1 Winsor green + indigo + Winsor violet

2 Winsor violet + French ultramarine

3 Winsor violet + French ultramarine + ivory black

4 Winsor violet + cerulean blue

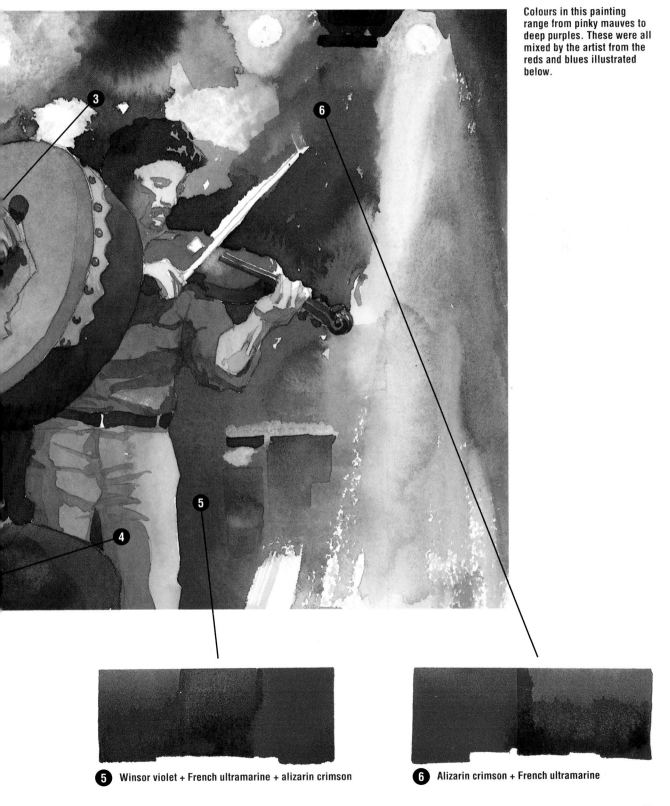

Colours in this painting range from pinky mauves to deep purples. These were all mixed by the artist from the reds and blues illustrated below.

5 Winsor violet + French ultramarine + alizarin crimson

6 Alizarin crimson + French ultramarine

PRACTICAL ORANGES

Unlike other secondary colours, a reasonable orange can be produced from combinations of almost all reds and yellows. The illustrations here show some of the possibilities, from the brightest obtainable mixture to a range of attractive 'burnt' oranges created from ochres and earthy reds. Good bought alternatives to mixed colours are Winsor orange and cadmium orange.

FRUIT WITH COTONEASTER

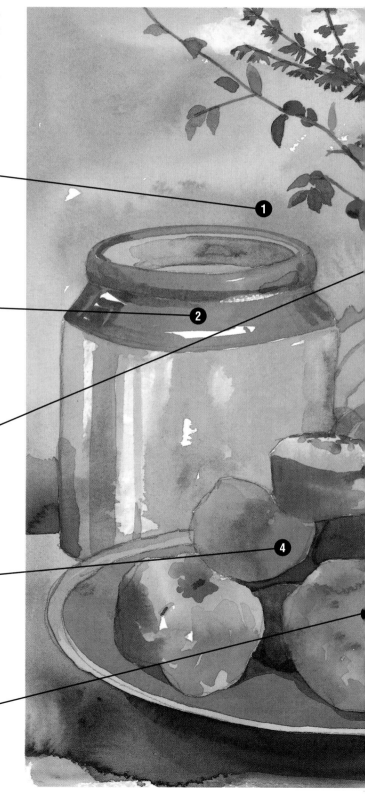

1 Venetian red + burnt sienna + cadmium yellow

2 Burnt sienna + raw sienna

3 Winsor orange + brown madder

4 Indian red + terre verte

5 Brown madder + raw sienna

52

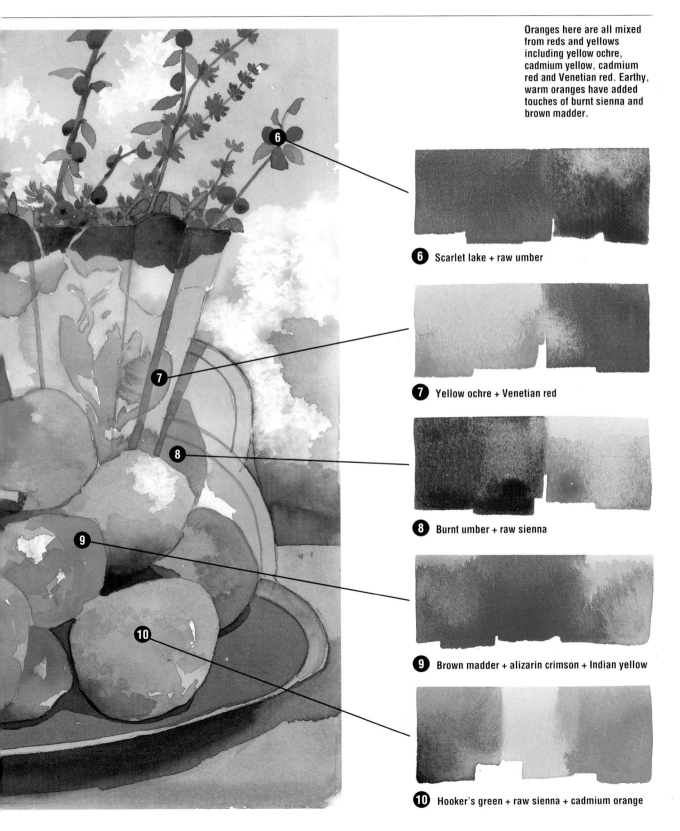

Oranges here are all mixed from reds and yellows including yellow ochre, cadmium yellow, cadmium red and Venetian red. Earthy, warm oranges have added touches of burnt sienna and brown madder.

6 Scarlet lake + raw umber

7 Yellow ochre + Venetian red

8 Burnt umber + raw sienna

9 Brown madder + alizarin crimson + Indian yellow

10 Hooker's green + raw sienna + cadmium orange

53

CONTROLLED BRILLIANCE

As all good chefs know, unlimited quantities of the very best ingredients do not amount to good cookery. A tasty dish is a delicate balance of a few select ingredients combined in the correct quantities, and the most successful recipes are often the simplest.

Exactly the same is true of painting. To capture vivid, sizzling colour is the ambition of many artists, but a vast number of brilliant colours does not ensure a brilliantly coloured painting. Ironically, too many bright colours can be counter-productive, because they tend to cancel each other out when applied indiscriminately.

Like the chef, an artist chooses the appropriate ingredients – a few colours, carefully selected to combine successfully in the finished painting.

Colour themes

For this still life, Shirley Trevena worked from a carefully chosen palette, varied enough to capture the colourful subject. She worked systematically, using the three main pairs of complementaries – red and green, blue and orange, and yellow and violet – bringing these together to create a picture which is both vivid and harmonious.

To give each complementary pair equal importance in the painting would have resulted in a bitty, confused image. Instead, the artist chose red as the dominant colour, so ensuring that the important complementary greens stand out. The strength of this red and green visual framework provides an ideal context for the other two complementary pairs.

Shirley Trevena is a colourist who plans her paintings from the moment she starts arranging the subject. For this composition she chose a bright red background which emphasizes the green objects – especially the melons. Bright oranges stand out against complementary blues, with added touches of complementary violet and yellow.

SLICE OF MELON

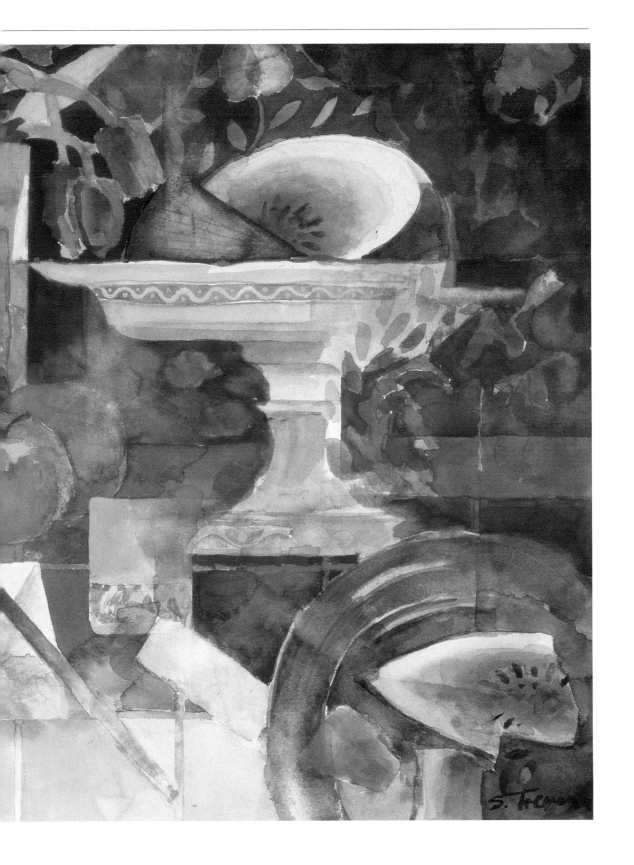

WHITE AND BLACK

WATERCOLOUR WHITES

The unique quality of watercolour paintings stems from the nature of the paints themselves, which are transparent and contain no chalk, or body colour.

Traditionally, watercolour is always used without the addition of white. The watercolourist plans ahead and leaves areas of the paper unpainted so that they will become highlights, or white areas of the picture. The use of white paint would effectively turn it into an opaque medium similar to body colour, or gouache.

However, the 'no white' tradition should not inhibit experiment. There is nothing to prevent watercolour and gouache from being used in the same painting without actually mixing the two types of paint – that is, using watercolour for the transparent washes, and opaque body colour for particular effects in certain selected areas. The painting on pages 60–61 is a good example of this. It is *not* the same thing as mixing the two types of paint together, which often results in a disappointing chalkiness.

Chinese white

The standard watercolour white is Chinese white. This is less opaque than gouache but nevertheless contains a certain amount of chalk, which works against the transparent nature of other colours when used in mixtures.

However, even those purists who adhere strictly to the 'no white' approach admit it entails a considerable amount of advance planning and leaves little room for error. Most artists limit the use of white by employing only small amounts to correct errors and make last-minute additions, such as highlights and reflections.

Unless you positively want a cloudy or opaque colour in a painting, a good general rule is never actually to mix white with other colours, but to reserve it for opaque effects only, and for touching up and correcting small errors.

Light to dark

The classical watercolour approach for obtaining whites and lights is to exploit the whiteness of the paper – that is, to leave unpainted those areas which are intended to be white in the finished painting, and to dilute colours with water in order to produce pastel shades and pale colours. This means a little advance planning, deciding in advance where the white and light areas will be and then applying the paint from light to dark.

A painting starts as a piece of white paper, and the artist builds up progressive layers of

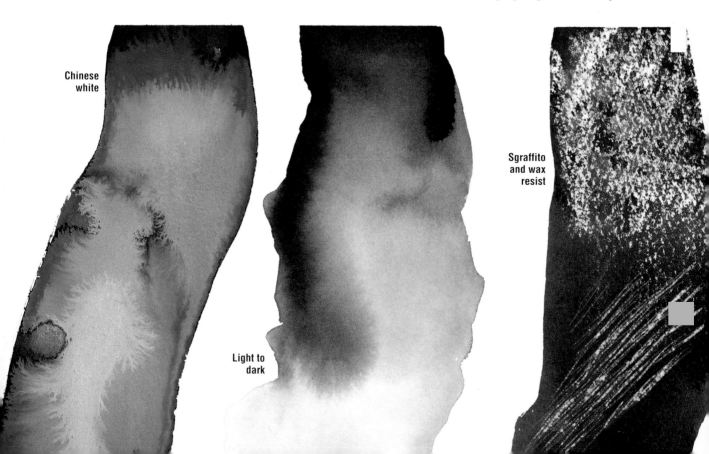

Chinese white

Light to dark

Sgraffito and wax resist

transparent colour, starting with the palest areas and working through to the final, darkest tones. Highlights and other white areas are represented not by white paint, but by patches of white paper which have been left untouched so that they show through between the painted areas.

Creating white textures

Although white paper is a crucial element in most watercolour painting, you are not restricted simply to leaving certain areas unpainted. There are other ways of exploiting the whiteness of the paper, some of which are also used to introduce textures and patterns in a painting.

The illustrations overleaf show different methods for creating whites in watercolour painting, with examples of how each technique is used in the context of particular subject areas.

Masking

In practice, working from light to dark is sometimes more difficult than it sounds, because it is all too easy accidentally to paint over those areas intended to be white. One answer is masking fluid – a rubber solution which is painted over those areas intended to remain white before starting to apply colour. Once dry, the masking fluid forms a

waterproof shield which protects the white paper from successive layers of paint. Masking fluid can be removed at any stage by rubbing with an eraser.

A note of caution: if masking fluid is left on a painting for several hours, it may be difficult to remove without damaging the surface of the paper. Also, when the mask is removed to reveal the white shapes, these often appear stark and bright compared with the rest of the painting. They may need to be softened with a light tonal wash.

Lifting colour

If a colour turns out to be too dark, this can be removed in various ways. Wet colour can be soaked up with tissue, the edge of a sheet of blotting paper, or a clean brush which has been squeezed dry. This has to be done quickly before the colour has time to sink into the paper; otherwise, the result is a pale mark rather than pure white. Even so, some watercolour pigments are extremely powerful and will leave an instantaneous stain. Dried colour can often be lightened, though usually not removed completely, by applying clean water to dissolve the colour, then lifting the paint in the same way.

Gum water and domestic bleach are also occasionally used for lightening colour.

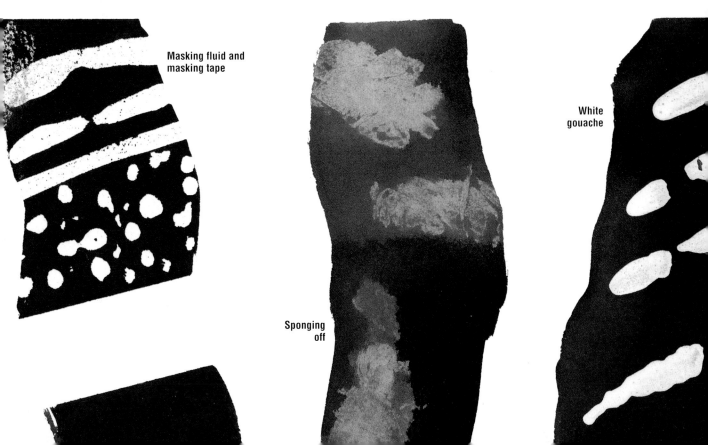

Masking fluid and masking tape

Sponging off

White gouache

THE RIGHT WHITE

How the paint goes on – or comes off – affects its texture and transparency in the finished picture. Technique therefore plays a vital role in the creating of whites.

This book is about colours and colour mixing, not painting technique, but the successful creation of white and light tones in watercolour is not simply a matter of mixing paint or exploiting the whiteness of the paper. Practical aspects, such as how the paint is actually applied, affect the resulting tones and colours, and learning a few straightforward techniques will open up the possibilities considerably.

Masking fluid, and lifting colour with a brush or tissue while the paint is still wet, have become standard watercolour techniques, but there are other, more unusual methods of creating whites and light tones in a painting.

White textures

Scratched textures, achieved by scratching into dry colour in order to reveal the paper underneath, can be done at any stage in the painting, including the final picture. Scratching, or sgraffito, is especially useful for creating small areas of fine white linear patterns, or an overall pale texture to lighten an area of solid colour.

Sponging or spattering paint with an old toothbrush creates a similarly textural effect, and adjoining areas of the picture can be protected with a paper mask. Although painted textures can be done in any colour, they are particularly useful for introducing whites into a watercolour painting which has otherwise become too dark.

WAYS WITH WHITE

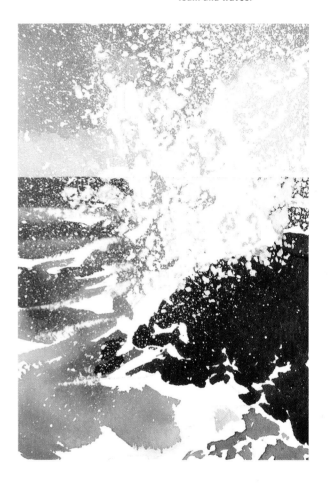

SPATTERING
White gouache spattered with a toothbrush is used for the foam and waves.

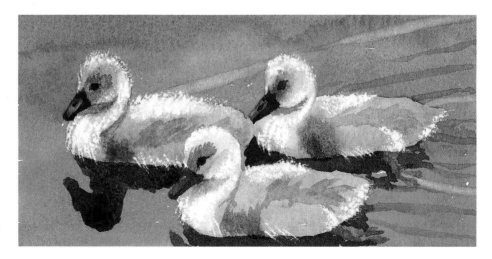

SGRAFFITO
The soft, downy texture on the ducklings is made by scratching dried colour with a sharp scalpel.

SPONGING OFF
Clouds and patches of sunlight are created by sponging off wet colour.

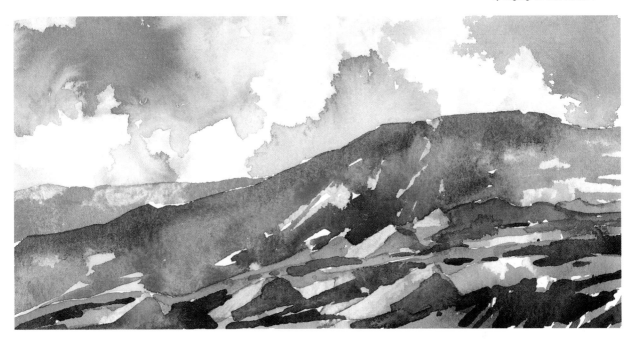

MASKING FLUID
Sharp hightlights on the snow are made with masking fluid applied with a brush.

WAX RESIST
Flower and cloud textures are created by using a household candle before applying paint.

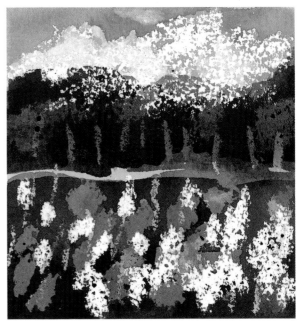

BODY COLOUR

Watercolour and body colour are compatible, which means that white gouache can be mixed with watercolour to produce opaque pastel tones. When a subject calls for bold splashes of white or light colour, the introduction of white paint is often the most effective way of achieving this. The trick is to use white only on certain parts, *not* to allow it to make the whole picture look chalky. Use Chinese white watercolour or white gouache in selected areas only, not in those places where the colours are intended to be translucent.

This beautiful tree painting by Leslie Worth contains body colour, yet retains the lightness of watercolour. The artist began with layers of transparent wash for the sky and grass. Yet for the cherry blossom, which dominates the composition, he used splashes of bold gouache, tinted with touches of watercolour to give the pink glow.

Gouache

Although gouache and watercolour are made from similar ingredients, and the two can safely be mixed together on the palette and used in the same painting, gouache colours are extended with white pigment or chalk, which make the colours opaque. Because of this added white, many gouache colours become paler as they dry, making it difficult to assess the tones and colours accurately while applying wet colour. In addition, the pigment particles used in the manufacture of gouache are not as finely ground as those used in watercolour and as a result the consistency of the paint is slightly coarser.

Like watercolour, most gouache paints are completely water-soluble, even after they have dried. However, watch out for some of the new varieties which contain plastic: once dried, these are permanent, and the colour cannot be lifted.

WHITE GOUACHE WITH WATERCOLOUR

Cadmium red

French ultramarine

Cadmium yellow

SPRING IN THE PARK

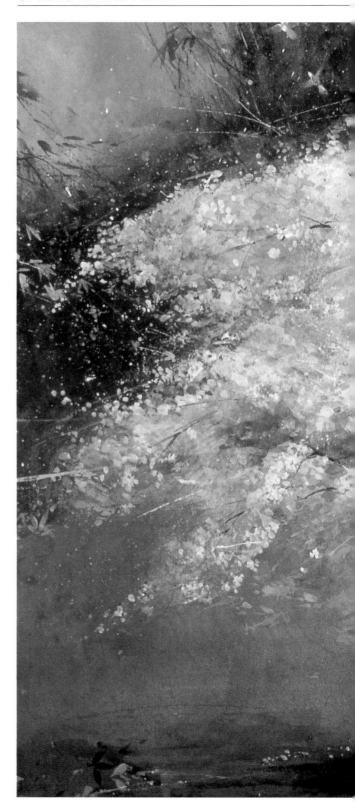

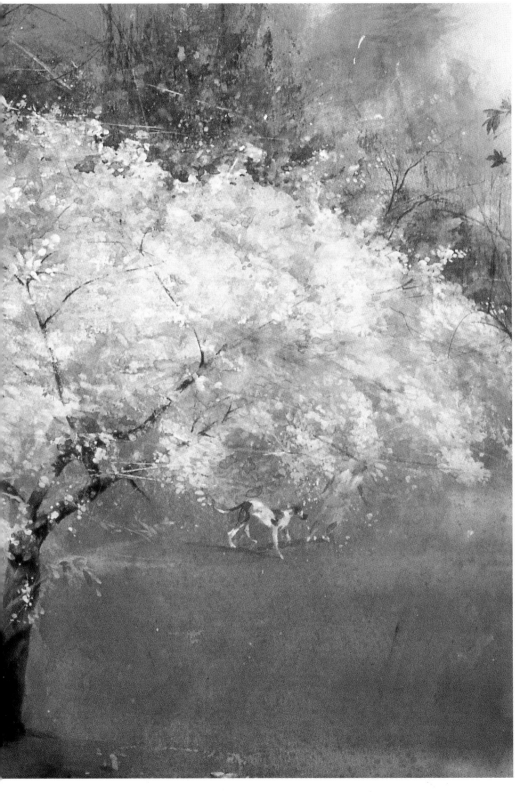

Leslie Worth combines pure watercolour with Chinese white or gouache to build up rich tones and textures in his work. In this painting he started with a light, graded wash to establish the sky and background. The cherry blossom is painted with watercolour mixed with opaque white.

MIXING BLACKS

Two standard blacks are used in watercolour painting: ivory black and lamp black. Applied darkly, with little added water, they both produce a dense, flat black and there is little visible difference between the two. Ivory black has been used for thousands of years and is still an all-round favourite with most artists. However, the slightly warmer lamp black is particularly effective for creating subtle gradations of tone, and is favoured by many watercolour artists for this reason.

There are conflicting views about the use of black. While some artists rely heavily on black for its extreme tonal contrast, others refuse to have it on their palettes because of its potentially deadening effect when used in mixtures. Instead, they prefer to mix black equivalents – dark tones mixed from other colours on the palette.

There is certainly an unfortunate tendency for newcomers to painting to use black automatically, simply because it is the most obvious and direct means of mixing dark tones. However, when this mixing is overdone, works often end up looking disappointingly dull and dirty, and many art teachers discourage the use of black for this reason.

Whether or not to use black is a personal decision, but even when there is no black paint on the palette, certain commonly used colours incorporate some black in their composition – including indigo and Payne's grey. Perhaps a sensible approach is to use black if you want to, but to be aware of the dangers of excess.

Mixing blacks

Obviously, true black cannot be mixed from other colours, but there are a surprising number of close equivalents. In addition, a 'black' mixed from colours used elsewhere in a painting ensures an overall harmony which pure black can sometimes destroy. For example, a dark neutral is mixed from primary red, blue and yellow. Often this provides an adequate equivalent to black, which can then be adjusted by altering the proportion of the primaries or by adding other colours.

Similarly, deep blue, such as cobalt or French ultramarine, combines with an umber or sienna to create a rich, dark tone which can be made warmer or cooler by varying the ratio of blue to earth colour, depending on what is required.

As these illustrations show, there are many lively possibilities. These are just a few, and it is worth experimenting to find other exciting alternatives to the automatic use of manufactured black.

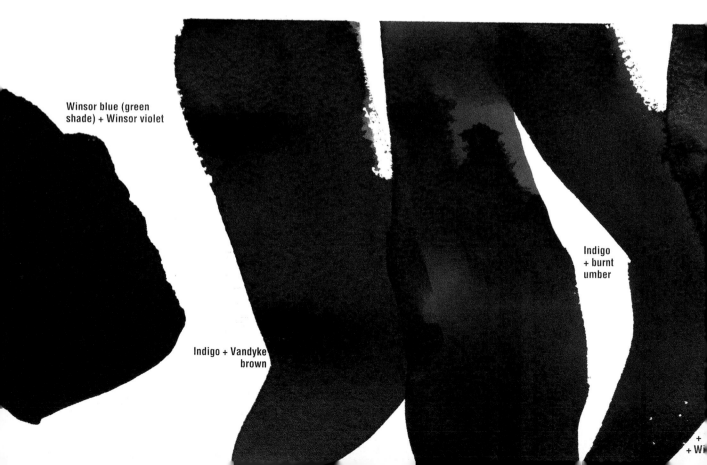

Winsor blue (green shade) + Winsor violet

Indigo + Vandyke brown

Indigo + burnt umber

FIGURE STUDY

The 'blacks' in this painting are taken from the mixtures illustrated below.

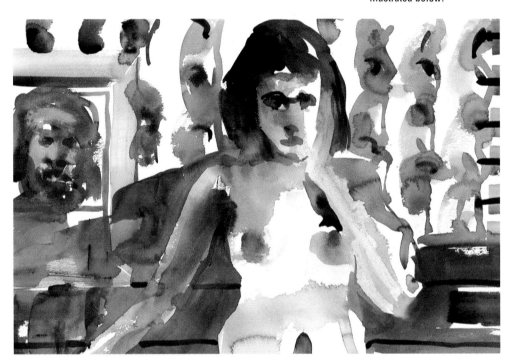

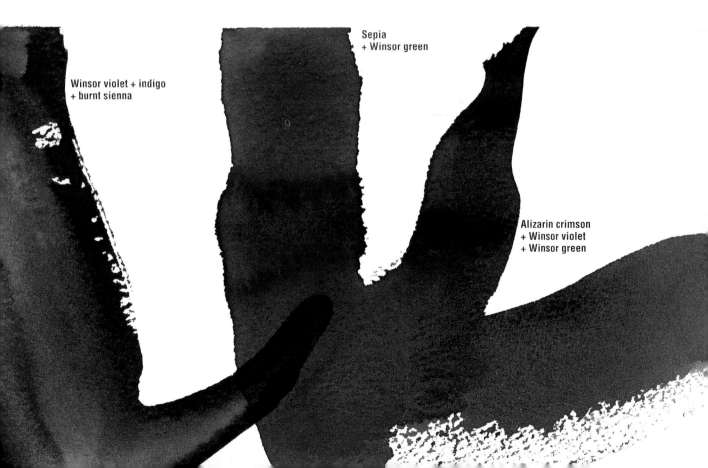

Winsor violet + indigo + burnt sienna

Sepia + Winsor green

Alizarin crimson + Winsor violet + Winsor green

NEUTRALS

Children tend to choose the brightest possible colours, regardless of what they are painting, and the results are usually charming. But for the artist, relentlessly bright colours in a work can be less appealing, and are not necessarily the trademark of a good colourist. In fact, unmixed colours often look crude – a tell-tale sign of lack of knowledge, especially if the subject is one which calls for subtle hues and muted tones.

It is frustrating to recognize and admire beautifully balanced colours in the work of other painters, and also to have the ability to see the same potential in a subject of one's own, while achieving the same effect in your own work may be a very different matter, with child-like brightness or muddy overmixing being the frequent result. Worse still, it is often difficult to know exactly what went wrong.

The solution is neutrals. The introduction of neutral colours allows you to use muted colours alongside bright ones, enhancing both but without losing the colour qualities of either.

True neutrals

The word 'pure' is applied to a primary colour or a mixture of two primary colours. As soon as you start to tone down a pure colour by adding an opposite colour, it loses its brightness and moves towards what is known as a neutral.

In practical terms, the neutrals are important because paintings are rarely executed in pure colours alone. If you always paint in pure colours, the effectiveness of individual colours is lost and the picture is rather flat, lacking in both form and interest. To be effective, pure colour needs the contrast of neighbouring or surrounding neutrals. Without this comparison its impact is lost.

Strictly speaking, a true neutral contains equal quantities of red, yellow and blue. However, by varying the quantities of each of the primaries you can mix what are sometimes referred to as 'coloured' neutrals – neutrals with a bias towards any one of the primary or secondary colours.

Mixing two opposite, or complementary, colours gives exactly the same results, with equal quantities of each complementary producing a neutral.

Obviously, for practical purposes, the term 'neutral' means any colour which has been toned down with an approximate opposite colour. For example, brown madder alizarin – a brownish red – is not on the colour wheel, but can be toned down with various greens. Similarly, sap green – again, not on the colour wheel – is toned down with bluish reds, browns and other warm neutrals.

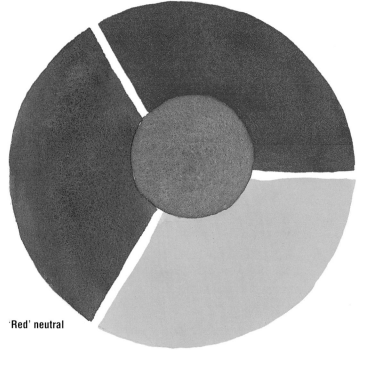

'Red' neutral

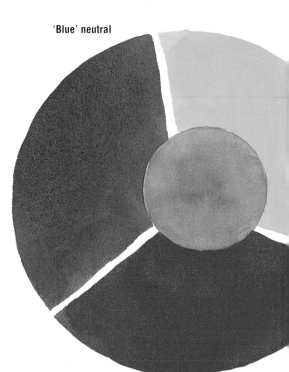

'Blue' neutral

GRINDSLOW KNOLL

The muted tones in this
landscape are achieved with
the use of 'neutral' mixes.

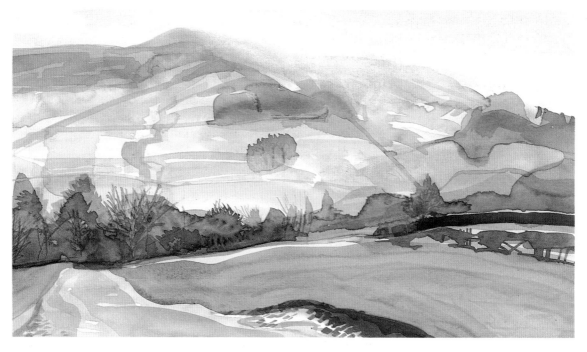

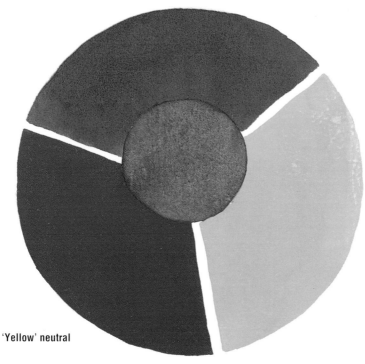

'Yellow' neutral

'Coloured' neutrals mixed
from the three primary
colours – red, yellow and
blue.

COLOURED GREYS

The purest watercolour grey is made by adding water to black paint. The more water, the paler the grey. Lamp black produces slightly warmer greys than those obtained from ivory black.

However, in real life pure grey is actually quite rare. Looking at the many greys around us, they all appear very different when seen next to each other. Apart from being lighter or darker, one has a slightly yellow tinge, another looks comparatively blue, and so on.

One way of achieving a 'coloured' grey is to add touches of the appropriate colour to diluted black. This works well in small areas but, as we know, too much black in a painting can be deadly dull. For those subjects which contain a lot of greys, it is often better to mix these without using black at all, from colours already present in the painting. Not only does this eliminate the dulling potential of black paint, but the results will be living colour rather than dead tones – live greys which will harmonize with the rest of the picture.

No black, no white

Mixing grey without black or white sounds odd, but is very effective. The white paper provides the white; other colours combine to produce the equivalent of black.

Much of the subject-matter in the illustration opposite is grey in colour – the water, trees and background – but the greys are all different. The artist has mixed them, not from black and white, but from a whole range of bright and pure colours.

The chart below shows some, but by no means all, of the many possible grey mixtures, including those made with black. They are not well-known recipes, simply the results of experiment.

MIXING 'GREYS'

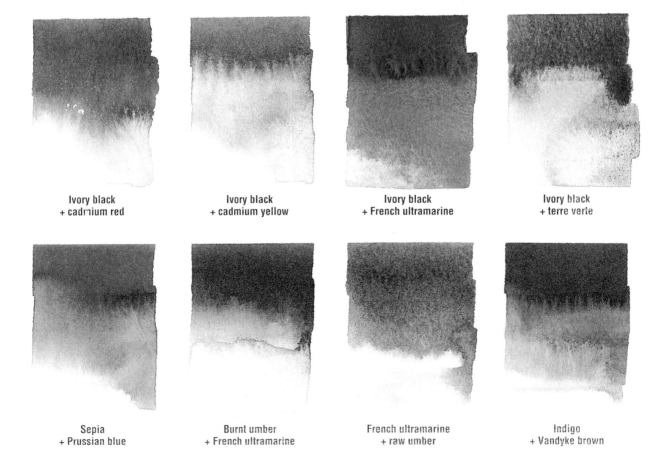

Ivory black
+ cadmium red

Ivory black
+ cadmium yellow

Ivory black
+ French ultramarine

Ivory black
+ terre verte

Sepia
+ Prussian blue

Burnt umber
+ French ultramarine

French ultramarine
+ raw umber

Indigo
+ Vandyke brown

THE THAMES AT RICHMOND

The 'greys' in this water-scape contain no black or white. They are mixed from other colours including indigo, cerulean blue, ultramarine blue, alizarin crimson and burnt umber.

1 French ultramarine + raw sienna + Payne's grey

2 Burnt umber + cobalt blue + indigo + alizarin crimson

5 Payne's grey + indigo + burnt umber

4 Cerulean blue + Vandyke brown

3 Burnt umber + French ultramarine + ivory black

67

THE EARTHS

Earth colours are rich and autumnal. Although they are popular in mixes, they are just as often used unmixed for the muted cool or rosy effects which they create.

The earth pigments include the siennas, umbers, ochres and terre verte. Light red and Venetian red are also earth colours, even though these pigments are now often manufactured synthetically. As their name suggests, earth colours come from the ground, from clays and silicates. It is perhaps this common source which makes the colours so distinctive and harmonious within their own colour group.

Harmonious earths

It is possible to paint using earth colours alone – the earliest known paintings were executed mainly in earth pigments. The range includes both cool and warm hues, and contains enough light and dark tones to accommodate many subjects – with the notable exception of those containing a lot of blue. As the paintings of our cave-dwelling ancestors show, there is no blue earth pigment.

All the earth colours provide a good starting point for colour mixing, and have a mellowing effect on stronger or more strident colours. Yellow ochre, for example, is popular in green mixes, producing useful and unusual greens when added to Winsor blue, viridian and other powerful pigments in the blue-green range.

Earthy tones

Raw umber is a dark tone and a popular substitute for black, especially when mixed with a little cobalt blue or French ultramarine.

Raw sienna and yellow ochre are similar in colour, and many artists regard the two as interchangeable, usually opting to have one or the other on the palette, but not both. Raw sienna is transparent and excellent in mixes, whereas yellow ochre is comparatively opaque. Yellow ochre has a greater covering capacity, but lacks the natural translucency of raw sienna.

The so-called 'burnt' earths are the result of roasting raw umber and sienna pigment to give it a burnt colour. The burnt earths are browner than their raw counterparts, and warmer in colour. However, the warmest earths are Indian and Venetian red. Again, the two are similar and artists tend to use one or the other rather than both.

EARTH PIGMENTS

| Raw umber | Burnt umber | Raw sienna | Burnt sienna | Yellow ochre |

IN ROSIE'S STUDIO

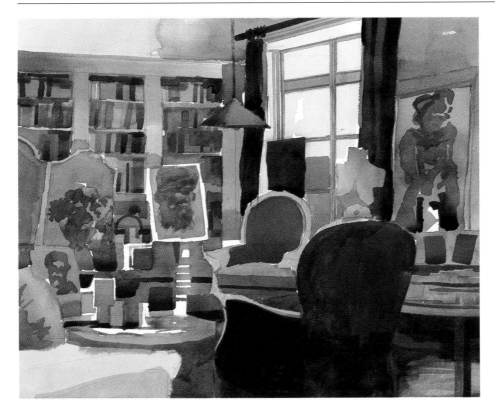

Earth colours are usually associated with the natural environment, but here they capture the muted golds and browns of a studio interior.

Earth colours come from natural and synthetic iron oxides. Olive green is a semi-earth colour, made partially from iron oxide.

Venetian red　　**Terre verte**　　**Light red**　　**Gold ochre**　　**Olive green**

COLOUR TONE

Every colour has a tone, and the simplest way to understand this is to imagine a black and white photograph of the subject. In this photograph, the blacks register as black, the whites as white. All other colours show up in varying degress of grey, ranging from very dark to very pale.

It is not always easy to pick out the tones of a subject: local colour gets in the way and makes the dark and pale areas difficult to identify. In this case, it can be helpful to look at the subject through half-closed eyes. This simple device cuts down the local colour and makes the tones more apparent.

Why tone?

There are two good reasons why an awareness of tone is crucial to the artist. Firstly, if the painted tones are not right then it follows that the colours must be wrong as well – either too light or too dark – because tone and colour are related.

As with colours, it is important that the overall tones in a painting relate accurately to each other. The lightness or darkness of each colour should be correct in relation to neighbouring colours. If these relationships are not accurate, the subject will lack a sense of space and three-dimensional form.

Extreme examples of poor tonal painting would be a landscape in which the distance was darker than the foreground, or a still-life in which the shadows were lighter than the local colour. The painting would simply look wrong.

With watercolour, accurate tones depend to a large extent on diluting the colours to the correct consistency. As a general rule, it is better to start off too light and make adjustments at any stage in the painting, than to apply colour which is too dark and has to be removed. For this reason, it is always best to test each colour for strength on a spare piece of paper before committing it to the picture.

Tonal composition

The second important consideration is the arrangement of the tones within the composition. Thoughtfully placed shapes and colours are automatic when planning a composition. Sadly, the lights and darks are often overlooked.

Again, it is helpful to think in terms of black, white and grey. View the subject through half-closed eyes, then make preliminary pencil sketches before starting to paint. This way, it is possible to plan exactly where the light and dark shapes will be, and how they will relate in the composition.

THE TONAL SCALE

Colour	Tone

Every colour has a tonal value between very pale and very dark grey. Each popular palette colour here is shown next to its tonal value.

CORNER OF THE SITTING ROOM

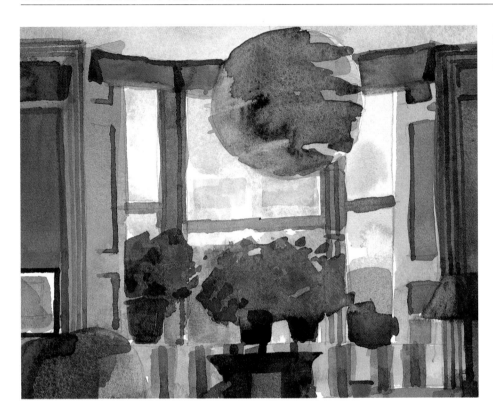

Contrasting lights and shades in this interior were painted using colours from the popular palette on page 38.

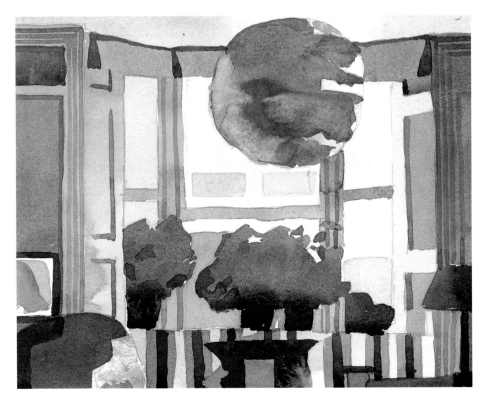

This monochrome version of the same subject shows the tonal values of all the colours used in the naturalistic painting above.

TONAL CONTRAST

Whenen a painting contains tones of extreme contrast, it is sometimes described as having a high tonal 'key'. This simply means that the artist has used the whole range of tones, from very dark to very light, or white.

Usually, the nature of the subject dictates whether or not the artist needs to work in a high tonal key. A subject which includes both black and white, for example, normally requires the whole range of tones, especially when the artist wants to paint a realistic or naturalistic representation.

Chiaroscuro

Artists of the Italian Renaissance coined the phrase 'chiaroscuro' to describe the dramatic effects of extreme light and shade. Highlights, visible beams of light, and sharply defined dark shadows which merge into an equally dark background are all typical of chiaroscuro painting.

A single source of light or any strong directional light always creates equally strong shadows. Subjects which are illuminated by such a light are normally painted in a high tonal key because one side of the subject is brightly lit, while the other is plunged into total darkness. The artist needs both the darkest and lightest tones available to capture this dramatic effect in a painting.

The Italians favoured chiaroscuro for painting figures and portraits, when a strong source of light was used to describe and emphasize the form of the human body, or facial features and expressions. But any single source of natural or artificial light falling on object or group of objects creates a similarly dramatic effect.

Colour and tonal contrast

Colour in chiaroscuro paintings often appears minimal – sometimes visible only where the light catches the subject. The rest of the composition is often an impression of overall darkness, with very little discernible colour.

In fact, the palette for such painting is no different from that used for painting a more obviously coloured subject, and the mixing process is exactly the same. As the painting opposite shows, dark tones and shadows do not necessarily mean more black: this painting was done without the use of any black at all.

CHIAROSCURO

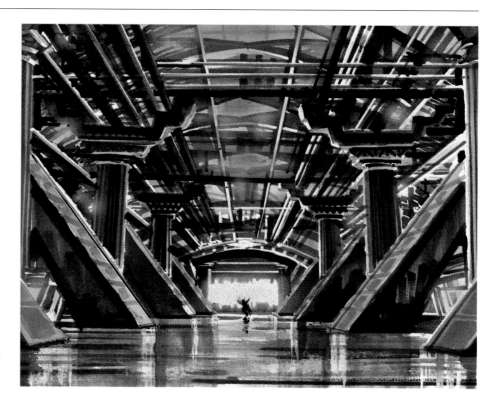

A design for a science fiction film showing the dramatic effects of chiaroscuro. Deepest shadows are painted in black; highlights are represented by white paper.

DESERT NOMAD

Strong sunlight creates strong shadows. The shadows here are clearly defined and appear almost black, although no black was used in the painting.

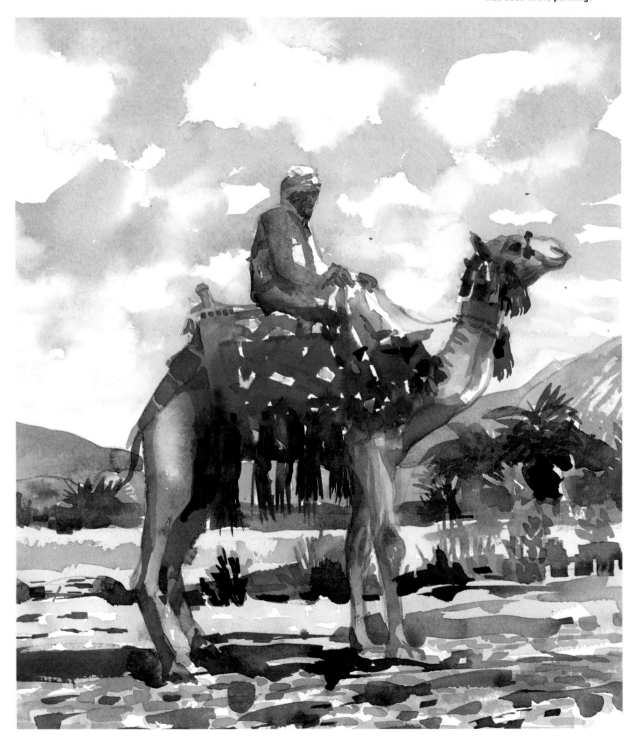

CLOSE TONES

There are no rules to state that a subject must be painted in a literal or truly representational manner. The artist is always free to experiment and make decisions, and this is certainly true when it comes to painting tones.

If this sounds contradictory, it simply means that the range of tones chosen for a painting need not imitate the exact tones on the subject. The palest subject can be painted darker than it really is, and a dark subject, such as a night scene, need not be as dark in a painting as it appears in real life. The important thing is that the painted tones must relate accurately to each other.

Choosing a tonal key

It is up to the artist to choose a personal key – to work within a chosen group of tones from any section of the tonal range. The selected key might exclude either all the light tones at one end of the tonal range, or all the dark tones at the other. Alternatively, any subject can be painted by using a group of tones from the middle of the range, without including any extreme lights or darks.

Inevitably, when working in a limited range of close tones, there is less dramatic contrast in the composition than one painted in starkly contrasting lights and darks. Instead, close tones are chosen for subtle or atmospheric effects.

Pale watercolour

Watercolours lend themselves to light tones, which is why many watercolourists work in a deliberately pale tonal range. Black was the darkest colour on the subject of the painting below, but because the artist worked in a pale key, most of the blacks are painted in medium-toned violets and greys. Thus, apart from a deliberate black focal area in the centre of the painting, all the tones fall between white and medium grey on the tonal scale.

In the painting opposite, the reverse applies. Dark colours in the subject and background are painted in similarly dark tones, but light colours are modified and painted slightly darker than they actually are. So, apart from a few contrasting whites, the tones in the painting fall between the medium and dark sections of the tonal scale.

SCRUB DESERT

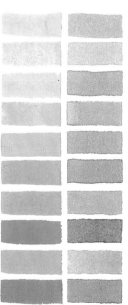

Colours apparently bleached by the sun prompted Adrian Smith to use a range of pale tones for this painting. The lightest tones are those in the far distance.

TULIPS AND WALLFLOWERS

Ivy Smith created a background of closely related deep tones for this jug of flowers. The dark background, painted in browns and neutrals, contains no stark tonal contrasts to detract from the main subject. Although the chair and space beyond are clearly defined, the dark tones ensure the background does not interfere with the brighter colours and tones of the flowers and jug.

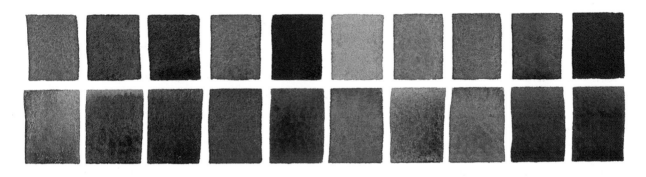

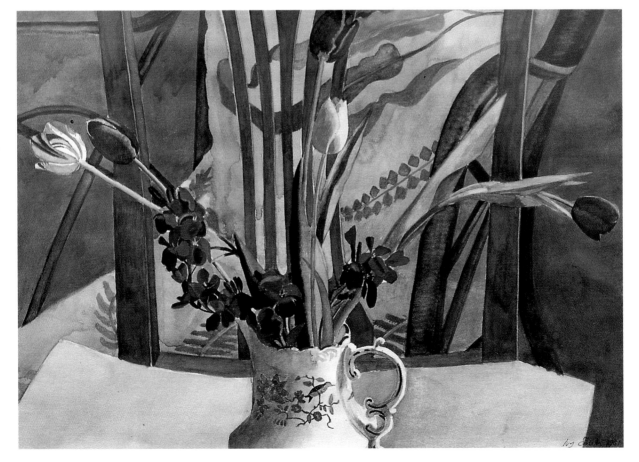

A PERSONAL CHOICE

Diluted watercolours can create an instantly pale tonal range. Thicker paints produce an opaque quality, similar to gouache or acrylic, enabling the artist to work entirely in dark tones. A combination of thick and thin paint provides the entire tonal range from dense black to the palest pastels, and is especially useful for painting subjects containing extreme tonal contrast. For example, the Venetian water scene on the opposite page contains both thick and thin colour.

As the illustrations on these pages show, the choice of tones – whether the painting is light or dark – often has more to do with the preference of the artist than with the tonal values of the subject.

CUMBRIAN VALLEY

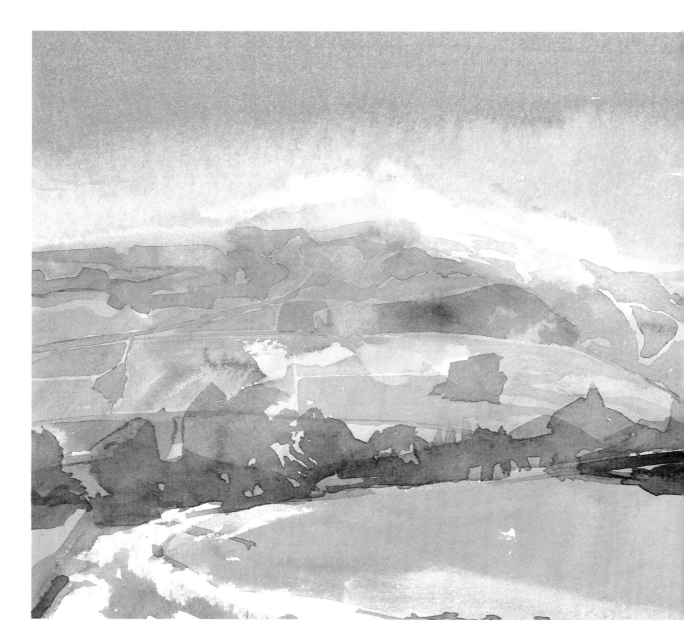

DAWROS BAY

The pale tone of the sky in this seascape is reflected in the water, contrasting sharply with dark rocks and headland.

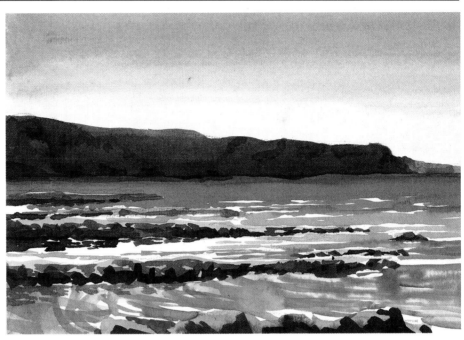

A landscape in washes of pale colour. Deep shadows are blackish grey, but diluted to lighten the tones.

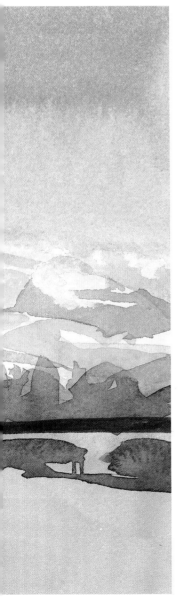

ISLE OF THE DEAD, VENICE

A dark tonal range is used to show silhouetted black shapes on the quay against the fading sunset.

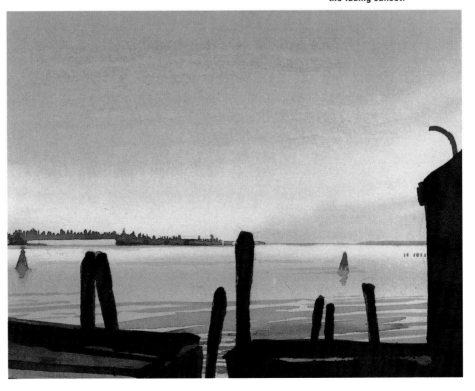

ON TONED PAPER

Watercolours painted on toned or coloured paper are quite unlike classical watercolour paintings, which are done on white or nearly white paper. On white paper, the transparent colours show up clearly and brightly. On toned and coloured papers, the underlying paper shows through the paint, affecting all colours, especially those which are very transparent such as the siennas, viridian and Hooker's green.

More opaque colours – such as yellow ochre, Naples yellow and cerulean blue – are less susceptible to the underlying paper colour and tone. Even so, unless the paint is applied very thickly, these too are affected to some extent. When dry, the chalkiness of the less transparent colours becomes more noticeable than when used on white paper. This is because the white in the paint shows up against the darker tone of the paper.

Chinese white or white gouache are virtually essential when working on coloured or toned and coloured paper, because without white it is almost impossible to create a practical range of light tones. Even on very pale papers, such as light grey and beige, the absence of white makes the overall painting look much darker than the comparatively light tone of the paper would suggest.

Paint and paper

The colour of the paper affects the painted colour in exactly the same way as if the paper colour had

SLIEVETOOEY

Watercolour with gouache on deep pink paper evokes the heaviness of a looming storm.

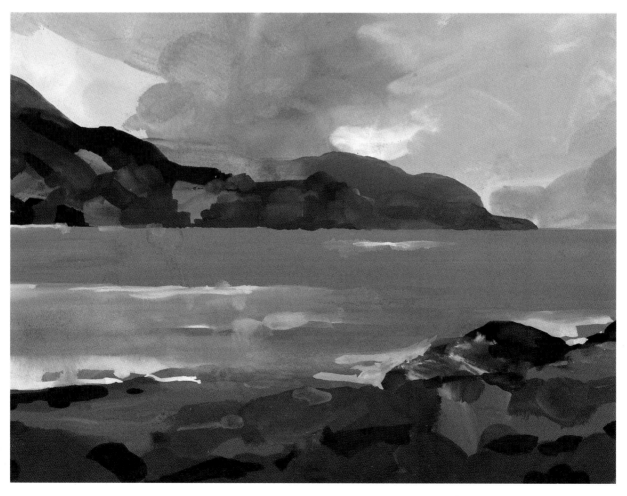

been mixed with the paint on the palette. For example, yellow paper makes blues appear green, and reds appear orange. Violet – the opposite of yellow – loses its colour and becomes neutral when applied to yellow paper.

One very positive aspect of working on coloured and toned papers is the harmonizing effect the paper colour has on the final painting. Just as some artists like to create harmony by mixing a little of one particular colour with every other colour used in a picture, so working on coloured papers has exactly the same effect. The paper colour 'mixes' with each of the painted colours to create a unifying theme which runs through the whole. Very brightly coloured papers are rarely used with watercolours because the strength of the underlying colour tends to overpower transparent pigments and delicate washes.

Warm and cool papers

A wide selection of papers in neutral and muted colours is available in art shops. Though not made specifically for watercolours, many of these are sturdy enough when stretched to take wet colour.

Neutral papers – the browns, greys and beiges – are particularly useful. These come in a wide range of tones from very light to very dark, and make excellent supports for watercolour painting, provided white is included in the palette. When selecting a paper, colour temperature is an important consideration. Browns, beiges and warm greys have a warming effect on the painted colours; cold greys make the colours appear cooler.

CHATSWORTH PARK

Pale grey paper is used for this medium-toned landscape.

STILL LIFE WITH FRUIT

Paints are dramatically affected by the colour of the paper. The same colours were used on orange paper (below) and blue paper (bottom).

SPECIAL PALETTES

MATCHING THE SUBJECT

Particular subjects often call for a special selection of colours. With so many colours to choose from, it is a pity not to take the opportunity to experiment with some of the more unusual ones.

For each of the paintings illustrated on the following pages, our artist chose an appropriate palette to suit the requirements of the subject. Sometimes, the colour selection varies only slightly from the basic popular palette discussed earlier. At other times, the artist uses an entirely new selection of colours, as in the palette chosen for the tropical garden of The New Oriental Hotel, below. But on the whole, the special palettes are more generally signified by the colours which have been left out. For example, two of the paintings shown here were painted without any bright reds.

THE NEW ORIENTAL HOTEL

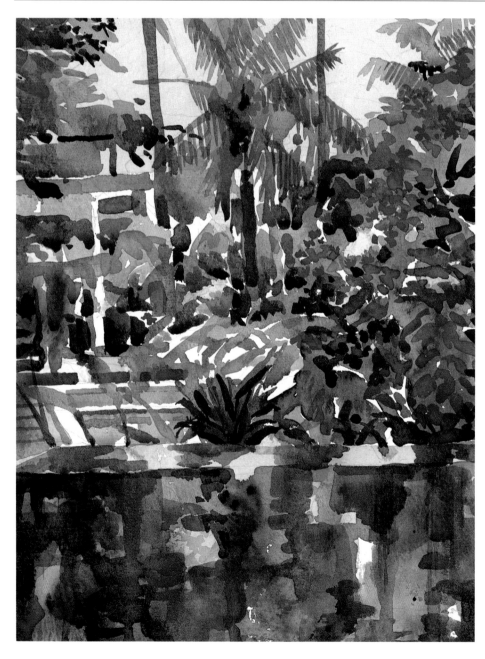

A tropical pool and exotic garden inspired our artist to try out one or two exciting new colours, including thioindigo violet.

Permanent rose

Thioindigo violet

Brown madder

Winsor lemon

Winsor green (blue shade)

Winsor blue (green shade)

THE LIGHTHOUSE

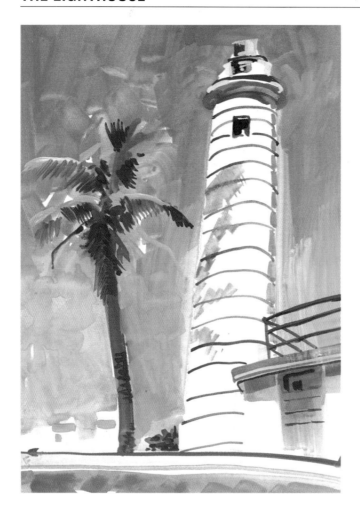

For this rapid, on-the-spot colour sketch, the artist chose colours present in the subject to avoid the need for a lot of mixing. The palette included Antwerp blue and cobalt turquoise.

Antwerp blue

Cobalt turquoise

Indian red

Viridian

Ultramarine violet

Naples yellow

KIRKLAND

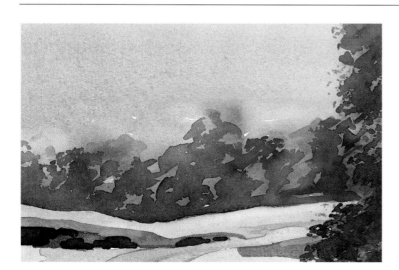

The light was vanishing fast, so the artist worked quickly with a minimal number of colours to capture light and shadow effects.

Nickel titanium yellow

Quinacridone gold

Prussian blue

Antwerp blue

MINIMAL MIXING

William Taylor is a landscape artist who works with as few colours as possible. His maxim: never mix three colours when two will do. Whenever he can, he uses a single, unmixed colour.

French ultramarine and raw sienna are the dominant colours in this mountainous landscape. Payne's grey is used for the darker tones, with touches of cadmium yellow and Winsor blue to brighten selected sky and foliage areas.

The artist began by washing diluted raw sienna over the warmer parts of the composition – the roofs, roads and some of the grass and trees. Into the wet wash he flooded a weak solution of French ultramarine to create patches of uneven green.

THE COLOURS

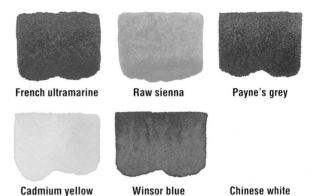

French ultramarine Raw sienna Payne's grey

Cadmium yellow Winsor blue Chinese white

SHEPHERD'S CRAG, BORROWDALE

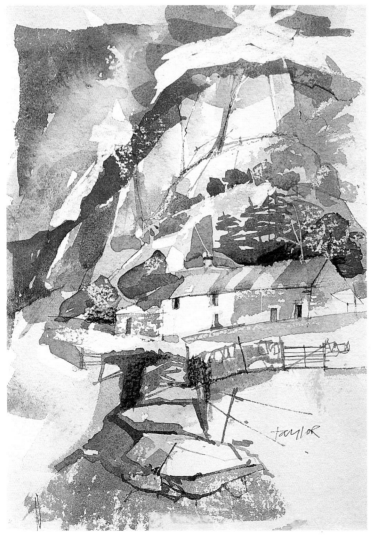

William Taylor is a landscape painter who works with a limited range of colours and likes to keep colour mixing to a minimum.

A hillside scene painted in just five colours with the addition of Chinese white.

PURE COLOUR

Audrey Hammond has 24 colours on her palette to achieve the vivid, luminous quality of the flowers she likes to paint. She never uses black, which would make the colours go muddy and dull. If she needs black as a local colour, an equivalent dark tone is mixed from Prussian blue, alizarin crimson and cadmium yellow.

Although the artist believes that nothing on her palette ever quite matches the colours of nature, she captures the translucency of petals by using two or more unmixed colours and allowing the wet paints to flow together on the paper. The red freesias are painted by flooding together permanent rose, alizarin crimson and cadmium yellow.

A BREATH OF FREESIAS

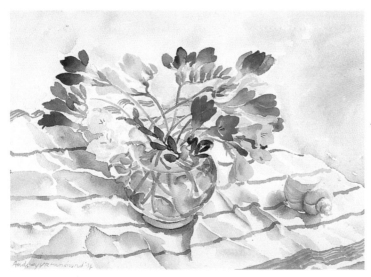

A simple flower subject painted in pure colours with no black or neutrals.

Audrey Hammond in her studio. The artist works from life, and likes to spend time choosing and arranging her flower and still-life subjects. Colour plays a major part in her paintings.

THE COLOURS

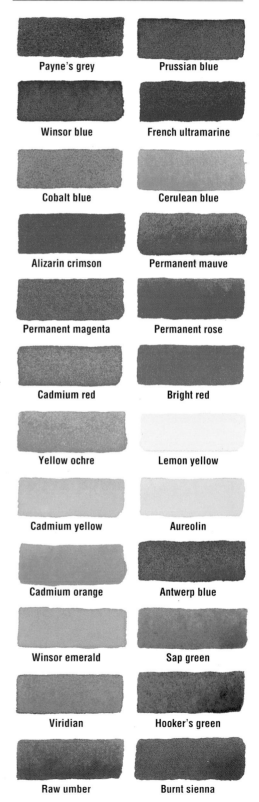

Payne's grey

Prussian blue

Winsor blue

French ultramarine

Cobalt blue

Cerulean blue

Alizarin crimson

Permanent mauve

Permanent magenta

Permanent rose

Cadmium red

Bright red

Yellow ochre

Lemon yellow

Cadmium yellow

Aureolin

Cadmium orange

Antwerp blue

Winsor emerald

Sap green

Viridian

Hooker's green

Raw umber

Burnt sienna

SATURATED COLOUR

Adrian Smith, who painted many of the illustrations in this book, uses a wide range of colours. His standard colours are those of the popular palette on page 38, but this is very much a starting point. He makes dramatic changes to this, depending on the light and colours of the subject.

The abstract composition below is based on a courtyard in Rajasthan and was painted during a visit to India, where light and colours were intense. To match the natural brilliance of the subject, he used watercolour and gouache in their most vivid and saturated form. In other words, colours are not dulled by adding black or other dark tones, nor are they lightened by diluting with water.

Adrian Smith in India, making sketches for future paintings.

BRAHMIN COURTYARD

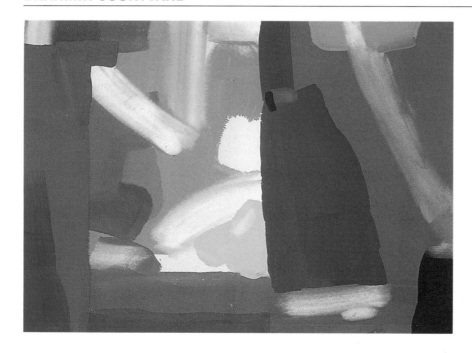

A doorway revealing splashes of orange, magenta and yellow – the colours of a painted courtyard – caught the eye of the artist as he walked down a street of decorated blue houses in Rajasthan. This abstract picture captures the intense colour of the scene.

THE COLOURS

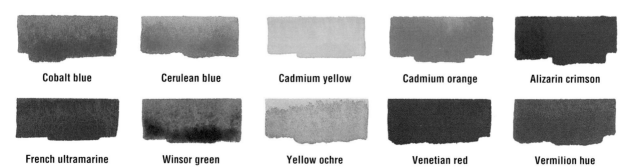

| Cobalt blue | Cerulean blue | Cadmium yellow | Cadmium orange | Alizarin crimson |

| French ultramarine | Winsor green | Yellow ochre | Venetian red | Vermilion hue |

SUBTLE TONES

For her watercolour paintings, Ivy Smith likes to work on the spot, painting directly from the subject. Her palette varies, but she tends to use strong colours, building these up layer by layer.

This autumn landscape is one of a series of ten paintings of the same subject. The series records different light, colour and weather conditions throughout the year. For this painting, the artist chose a palette of warm earth pigments, with alizarin crimson, lemon yellow and cadmium yellow for the rich, autumnal colours.

(Ivy Smith not related to Adrian Smith, opposite.)

Ivy Smith at work in her studio. Her subject range includes portraits, figures and still-life arrangements as well as landscapes. She changes her palette according to what she is painting.

NOVEMBER POND

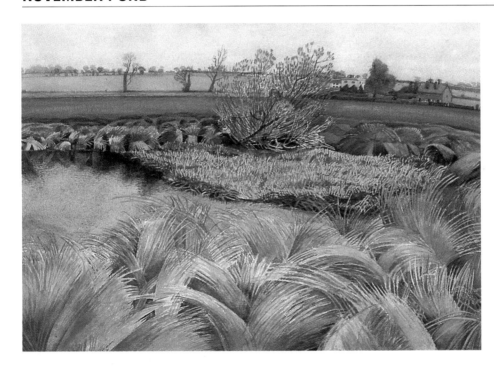

There was no preliminary pencil drawing for this painting. Instead, the artist made a light outline sketch in paint before starting to apply colour.

THE COLOURS

Cobalt blue

Alizarin crimson

Yellow ochre

Burnt umber

French ultramarine

Lemon yellow

Burnt sienna

Cadmium yellow

COOL SUBJECTS/1

Shadows are cool and dark, and shady subjects inevitably include cool colours. This riverside scene is overhung with large trees which block out direct sunlight and prevent the sun from casting pale reflections on the surface of the water. However, this intensity of shade does not eliminate the colours. It simply darkens them.

Woods in the background are built up with overlaid washes, starting with mixtures of alizarin crimson and earth colours. This warm underpainting is then painted over with layers of indigo and deep blue, and for the tree shapes raw sienna is added to this mixture. In some areas, two or more wet colours are allowed to run together, so creating an amorphous, marbled effect.

Tonal contrast

Colours and tones are enlivened by the paler shades on the boat and house. Here, the artist has deliberately left flecks of white paper showing through the paint. These provide a necessary contrast to the otherwise dark tones of the painting.

THE COLOURS

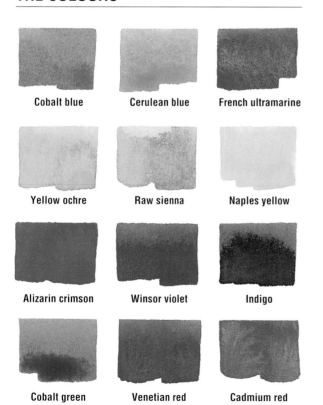

Cobalt blue	Cerulean blue	French ultramarine
Yellow ochre	Raw sienna	Naples yellow
Alizarin crimson	Winsor violet	Indigo
Cobalt green	Venetian red	Cadmium red

THE LADY JANE

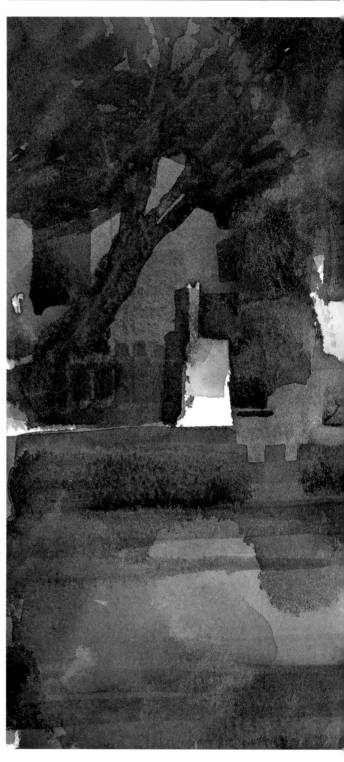

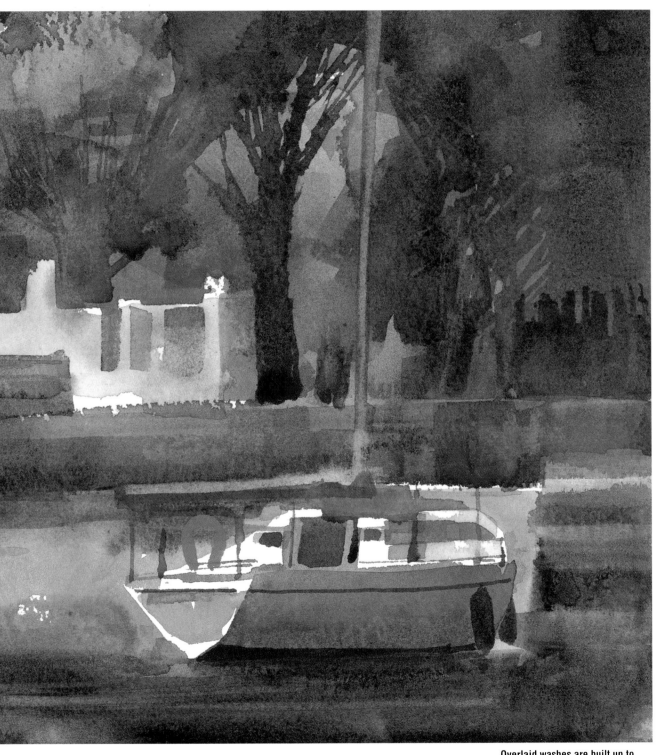

Overlaid washes are built up to
create the deep, cool colours of
this shady backwater.

COOL SUBJECTS/2

One of the Seven Wonders of the World – not by moonlight, but painted at dusk, when fading light cast a cool blue shadow on the glistening white marble. Like many architectural subjects, the Taj Mahal looks complicated, but the overall whiteness of the building and the saturated blueness of the evening light had a unifying effect which enabled the artist to simplify the colours of the subject.

Much of the carving and intricate detail has also been left out as the artist aimed to create a general impression, painting only what was visible in the evening light. For instance, doors, windows and archways are simplified as shapes of colour.

Economy of colour

There were only six colours on the artist's palette although, at first glance, the picture appears to be painted in just two – blue and the reddish brown of the foreground. In fact, the artist worked from a selection of colours which, unusually, included three different blues – indigo, cerulean blue and French ultramarine. Warm areas on the building were created by adding touches of sepia, Indian red and aureolin to the mixed blues.

Despite this limited range, the artist was able to create the dramatically dark shadow of the foreground arch and the contrasting bright tones of the building itself. The foreground, too, is deceptively simple, with Indian red, sepia and some of the mixed blues being used to create the warm red tiles and the cool, dark shadows. Blackish tones are mixed mainly from Indian red, sepia and indigo.

THE COLOURS

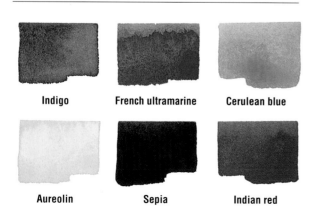

Indigo **French ultramarine** **Cerulean blue**

Aureolin **Sepia** **Indian red**

1

Indigo + Indian red + sepia

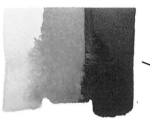

2

Aureolin + cerulean blue + Indian red

3

French ultramarine + aureolin + indigo

4

French ultramarine + indigo

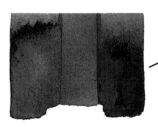

5

Sepia + Indian red + indigo

TAJ MAHAL

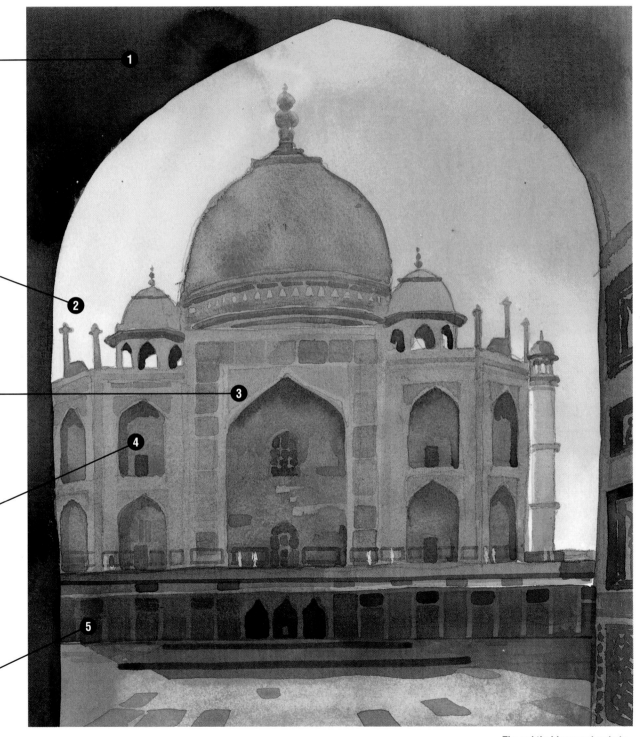

The subtle blues and reds in this painting are mixed from a palette of six colours which includes three blues.

WARM SUBJECTS/1

Lighting often dictates the warm and cool colour content of a subject. The local colours of this Egyptian landscape are all warm – the colours of sand and sandstone. Yet the strong light creates cool shadows which are as essential to the painting as the yellows and oranges of the desert sand.

Our artist chose a palette of 12 colours to meet the requirements of this multi-coloured subject, which ranges in temperature from very warm to very cool. The palette consists of four earth colours – yellow ochre, burnt umber, burnt sienna and raw sienna – as well as cadmium yellow pale, cadmium orange and brown madder. Shadows are mixed mainly from blues, Winsor violet and black.

Simplified colour

The subject is complex, and it is not easy to distinguish the individual buildings. To paint this, the artist started with a precise line drawing. Houses and buildings were then simplified as blocks of flat colour – earthy pinks and yellows for the sunlit walls, cool purples for the shaded areas.

THE COLOURS

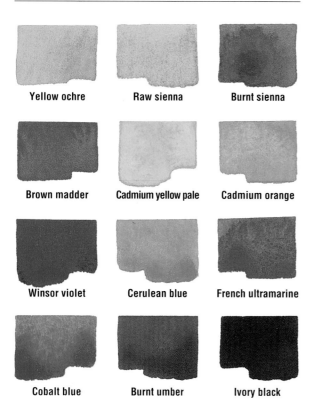

Yellow ochre	Raw sienna	Burnt sienna
Brown madder	Cadmium yellow pale	Cadmium orange
Winsor violet	Cerulean blue	French ultramarine
Cobalt blue	Burnt umber	Ivory black

SALADIN'S CITADEL, CAIRO

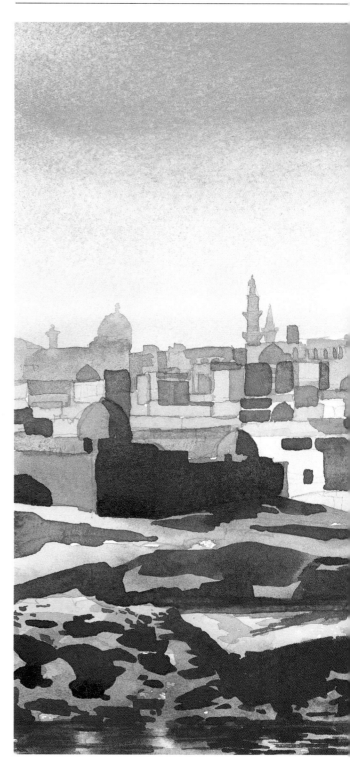

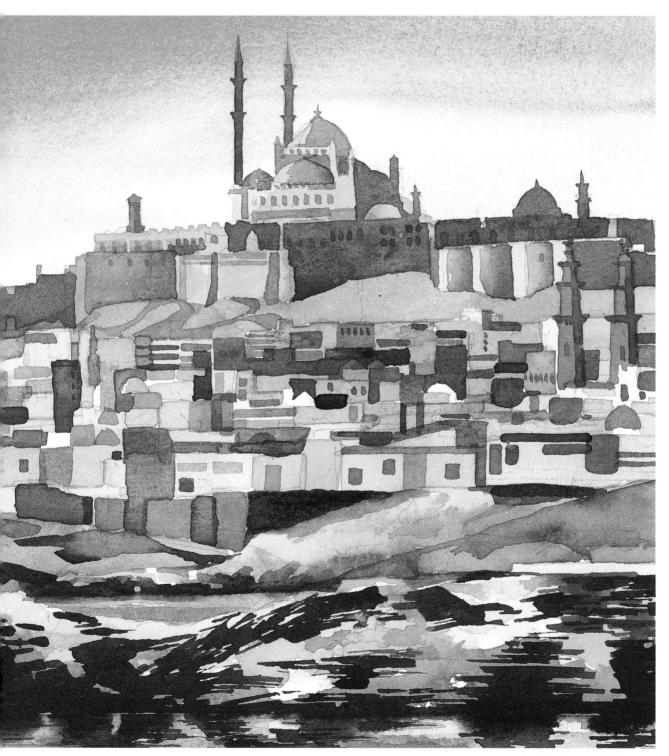

Sandy yellows and beiges are emphasized with contrasting deep violet shadows.

WARM SUBJECTS/2

This eye-catching watercolour is an illustration for a magazine restaurant review. The artist was asked to produce a painting which looked both cheerful and appetizing. With this in mind, he chose warm reds, oranges and yellows. He also selected a few contrasting cool colours.

Bright, warm colours appear to jump forward from the picture plane; cooler colours tend to recede. Warm colours are especially striking when patches of white paper are allowed to show between areas of bright colour, as they do in this painting. The white areas separate bright colours, making individual colours appear even brighter.

The subject is painted graphically, as a stylized arrangement of flattened shapes and simplified colours. There is little indication of three-dimensional form on any of the objects, because cool shadows are practically non-existent. Instead, violet, green and blue, normally used for shadows, are here used as local colours in specific areas. Mixing and diluting were kept to a minimum, and the resulting colours are all pure and bright.

THE COLOURS

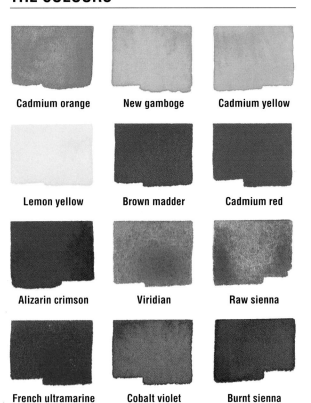

Cadmium orange **New gamboge** **Cadmium yellow**

Lemon yellow **Brown madder** **Cadmium red**

Alizarin crimson **Viridian** **Raw sienna**

French ultramarine **Cobalt violet** **Burnt sienna**

1
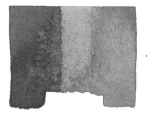
Burnt sienna + raw sienna + cadmium orange

2

Brown madder + burnt sienna + alizarin crimson

3

French ultramarine + cobalt violet + raw sienna

4

Raw sienna + burnt sienna

5

Brown madder + cadmium orange + cadmium red

AUBERGE DE LA TOUR

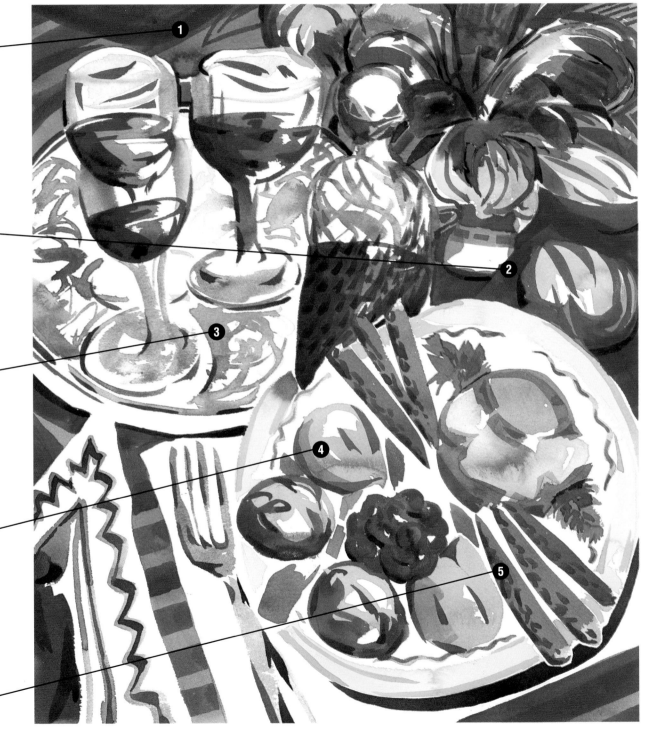

An illustration for a restaurant review. Warm, welcoming colours are used to depict a tempting dinner table.

PORTRAITS/1

In the early Renaissance, before watercolour was in general use, artists developed an effective formula for capturing the translucent quality of skin using comparatively opaque fresco and tempera techniques. The first layer was a flat underpainting in terre verte, a dark earth green. Subsequent layers of warmer flesh colours were applied thinly over this, allowing the green to show though in the shaded areas.

More recently, the transparent quality of watercolour has made this technique easier. It allows the artist to capture the glowing translucency of flesh tones by overlaying two or more layers of diluted colour. Undercolours show through subsequent layers of colour.

Skin types

A similar palette is appropriate for all skin types. Ethnic differences and variations in the local colour are usually achieved by altering the warm and cool mixtures in the painting, not by using a different set of colours. For example, many black African skins are cooler than most fair skins. There is usually less red and yellow in the highlights, more blue and green in the shaded areas. However, the basic palette is the same.

THE COLOURS

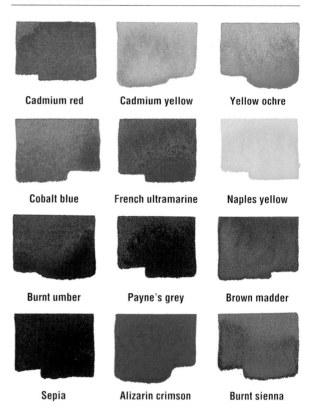

Cadmium red Cadmium yellow Yellow ochre

Cobalt blue French ultramarine Naples yellow

Burnt umber Payne's grey Brown madder

Sepia Alizarin crimson Burnt sienna

SKIN COLOURS

WARM TONES

Alizarin crimson + yellow ochre

Cadmium red + cadmium yellow + brown madder

Naples yellow + cadmium red + burnt umber

Naples yellow + cadmium red + sepia

COOL TONES

Alizarin crimson + cadmium yellow + cobalt blue

Cadmium red + burnt sienna + French ultramarine

Naples yellow + cadmium red + Payne's grey

A few of the many warm and cool skin tones which can be mixed from the above palette.

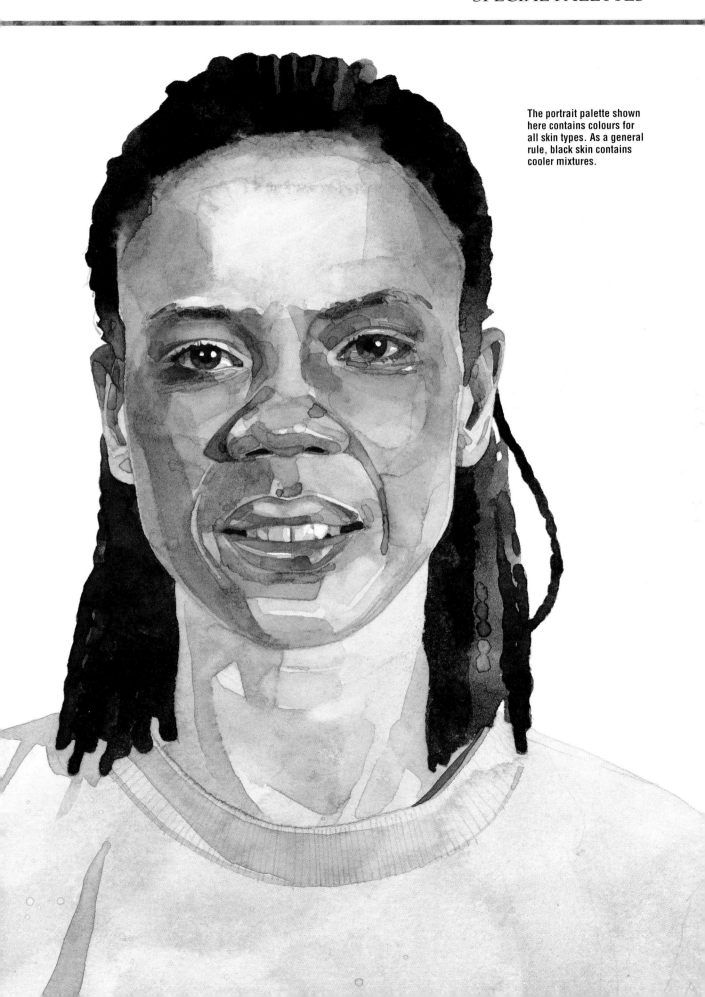

The portrait palette shown here contains colours for all skin types. As a general rule, black skin contains cooler mixtures.

PORTRAITS/2

Human skin actually has no easily identifiable colour, because flesh tones change from warm to cool depending on the light and the light source. In addition, flesh is translucent – the result of semi-transparent layers of skin. It is not a solid mass of opaque colour.

The face is a complex structure made up of a number of interlocking forms: the facial features. Features are more easily visible when the subject is illuminated from one side, thus throwing one half of the face into comparative shade. Front lighting makes the face look flatter than it really is, and for this reason is usually avoided by portrait painters.

Even with a strong side light, the rounded forms of the face and features can make it difficult for the artist to differentiate between the tiny areas of light and shade, or to pick out subtle areas of colour. For the artist, simplification is usually the best solution.

Facial planes

A face is made up of tiny surface areas, or planes. Planes facing the light are pale and warm; planes facing away from the light are darker and cooler.

For this portrait, the artist simplified the facial planes by establishing each one as a bold area of colour. Bright highlights are represented by the whiteness of the paper; other illuminated areas are mixed mainly from reds and yellows. Shaded colours are cooled with added blue, violet or green.

THE COLOURS

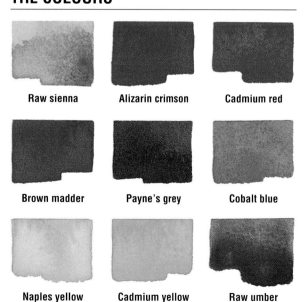

Raw sienna

Alizarin crimson

Cadmium red

Brown madder

Payne's grey

Cobalt blue

Naples yellow

Cadmium yellow

Raw umber

 1

Alizarin crimson + Naples yellow + Payne's grey

 2

Payne's grey + brown madder + raw sienna

3

Cadmium yellow + raw sienna + cadmium red

 4

Alizarin crimson + raw umber + Payne's grey

 5

Brown madder + raw sienna + cobalt blue

WOMAN IN BLUE

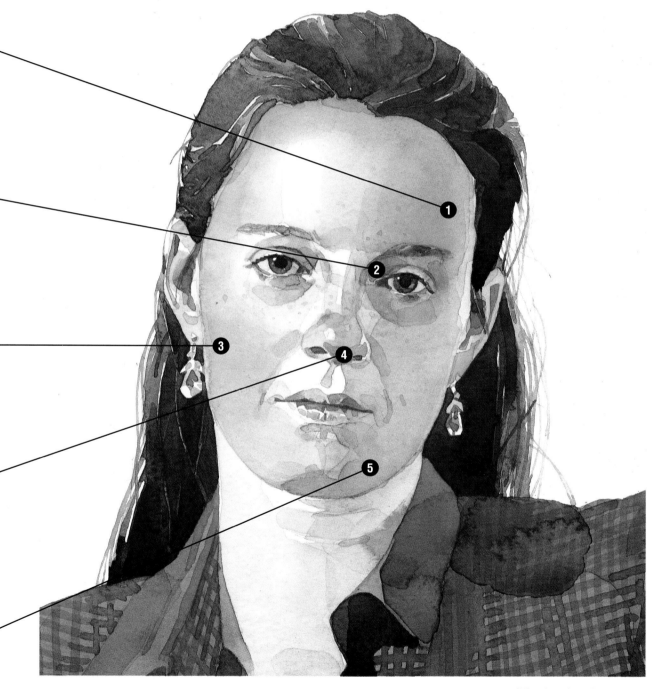

Diluted washes of warm and cool colour are overlaid to create the lights and shades of skin tones in this portrait.

THE FIGURE/1

Many artists like to make rapid colour sketches of a subject before starting work on a final painting. These sketches give the artist an opportunity to simplify tones and colours and to work out a suitable palette in advance .

These preliminary sketches, or 'roughs', are essentially experimental and usually contain less detail than a finished painting. However, in many ways a colour sketch can be more successful than a finished painting. This is especailly so with figure painting, when a spontaneous impression is more likely to capture the movement and fluidity of the human subject than a more detailed rendering.

Colour sketching

The lively figure sketch opposite is painted in bold, loose brush strokes. The artist has simplified the main forms – the torso and limbs – painting these as broad planes of warm and cool colours. Planes nearest the light source are pale and warm; cool, shaded planes contain blue, green and grey. Alizarin crimson, a cool red, provides a useful link between very warm and very cool colours. In this painting, alizarin is used on areas which connect planes of extreme light and shade.

While working on this sketch, the artist was able to experiment and make decisions about colour and tone without worrying too much about other aspects of the subject.

THE COLOURS

Brown madder

Raw sienna

Alizarin crimson

Ivory black

Winsor blue

French ultramarine

Raw umber

Burnt sienna

Indian red

1 Brown madder + raw umber + French ultramarine

2 Raw sienna + brown madder

3 Winsor blue + alizarin crimson + raw umber

4 Raw sienna + Indian red + Winsor blue

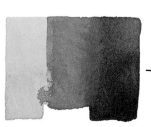

5 Raw sienna + burnt sienna + ivory black

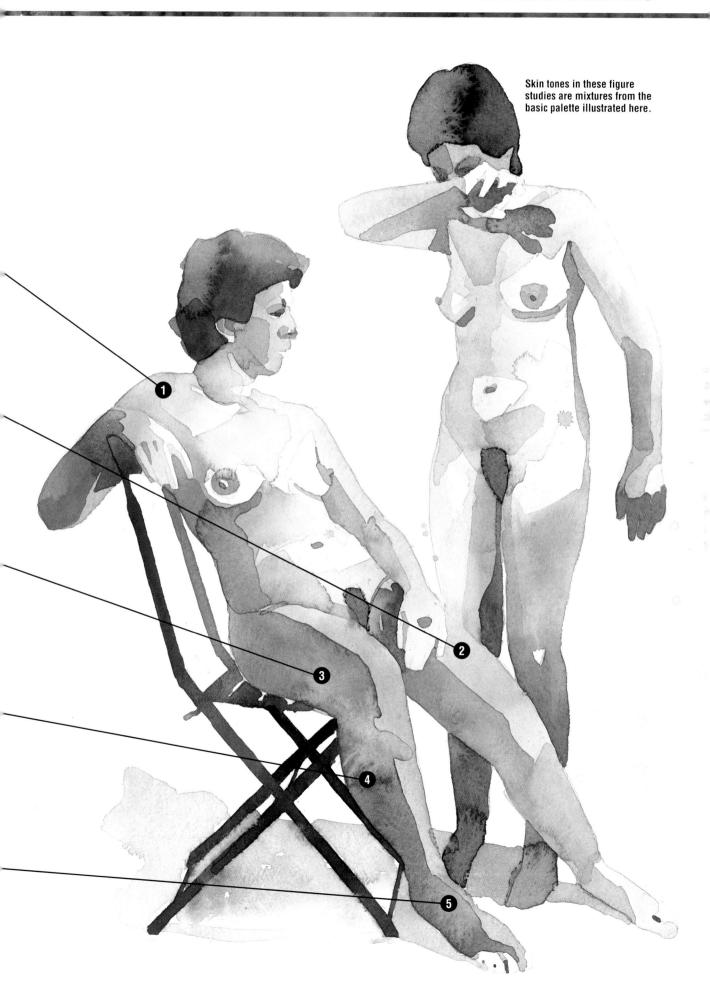

Skin tones in these figure studies are mixtures from the basic palette illustrated here.

THE FIGURE/2

It takes only a handful of colours to create an enormous range of flesh tones – a selection of mixtures wide enough to cope with any human subject. However, more than for any other subject, the initial selection of palette colours is of particular importance when it comes to painting figures.

Light and shade, skin tone, changes in local colour from one part of the body to another – the subtle and integrated effects created by all these factors must be mixed from a limited number of palette colours.

Reflected colour

Painters and teachers often arrange bright drapes and patterned fabrics around their figure-painting models. These colourful props are not simply for

decoration, put there for the sole purpose of improving the composition or brightening up the picture: they also make a vital contribution to the quality of colour within the figure itself.

Skin reflects and absorbs surrounding colours, and the flesh tones of a nude figure are inevitably affected by the colours of the room in which he or she is posing. For example, the colour of a fabric draped over the chair of a seated nude casts a shadow over certain parts of the body – a shadow which contains visible traces of the fabric colour. Similarly, a coloured wall behind a nude model will be reflected in both the light and dark tones of the model's skin.

Light itself has a colour. Cold daylight can appear white or blue when reflected on the skin of a figure standing out of doors or against a window. Alternatively, artificial lighting may be orange or yellow in colour, and this too will directly affect the appearance and colour of human skin.

THE COLOURS

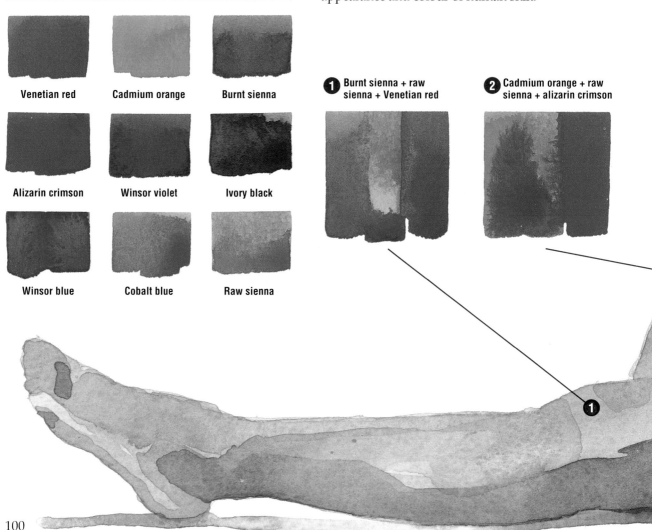

Venetian red

Cadmium orange

Burnt sienna

Alizarin crimson

Winsor violet

Ivory black

Winsor blue

Cobalt blue

Raw sienna

1 Burnt sienna + raw sienna + Venetian red

2 Cadmium orange + raw sienna + alizarin crimson

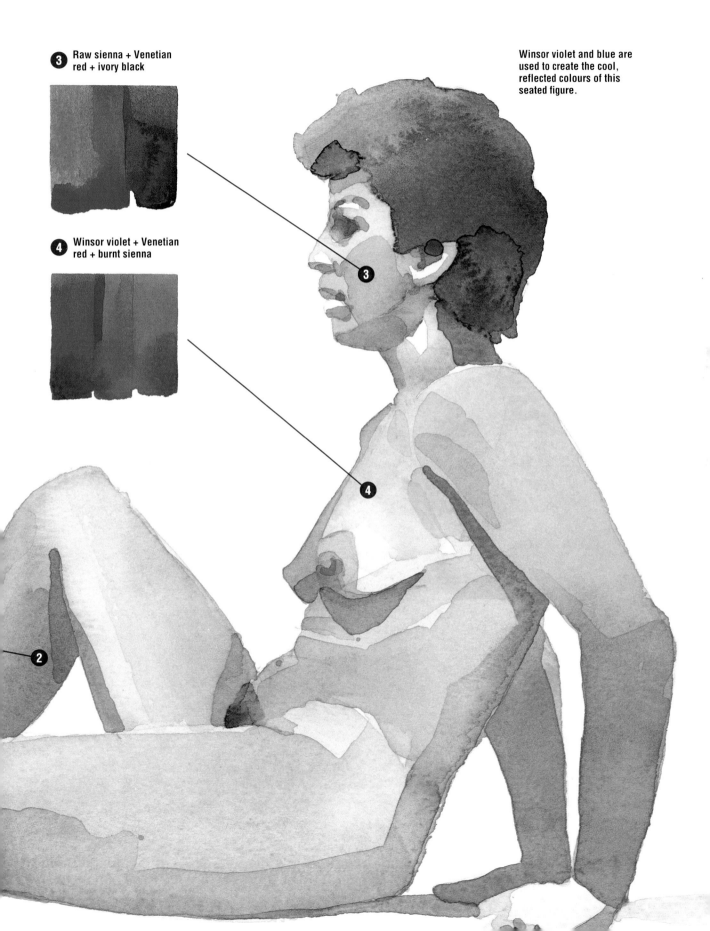

3 Raw sienna + Venetian red + ivory black

4 Winsor violet + Venetian red + burnt sienna

Winsor violet and blue are used to create the cool, reflected colours of this seated figure.

ARCHITECTURE/1

Why not, for a change, abandon the creations of nature and look for inspiration in the often controversial structures created by the human mind? The modern urban landscape is not always picturesque, but it is often interesting. For the painter, it provides a chance to escape from the predictable and to experiment – to create a painting from geometric shapes and monumental forms.

The brightest colours in cities are usually to be found at street level – on vehicles and shop fronts, and on the clothes of the pedestrians. The buildings themselves are constructed mainly from manufactured materials such as concrete, glass and steel, and are often neutral or grey in colour.

Although greys are the dominant colours in this New York street scene, they are not mixed from black and white. They are coloured greys, mixed from raw sienna, brown madder, Winsor violet and other colours on the palette opposite.

Simplified colour

As with all architectural subjects, correct perspective and scale are important in this urban landscape. The solution: to make an accurate line drawing, establishing the perspective and composition of the subject before starting to paint.

To avoid a tight, topographical image – a painting which looks more like an architect's plan than a watercolour – the artist then applied loose colour over the line drawing.

DOWNTOWN MANHATTAN

Coloured greys are used to depict directional light and shade in an urban landscape.

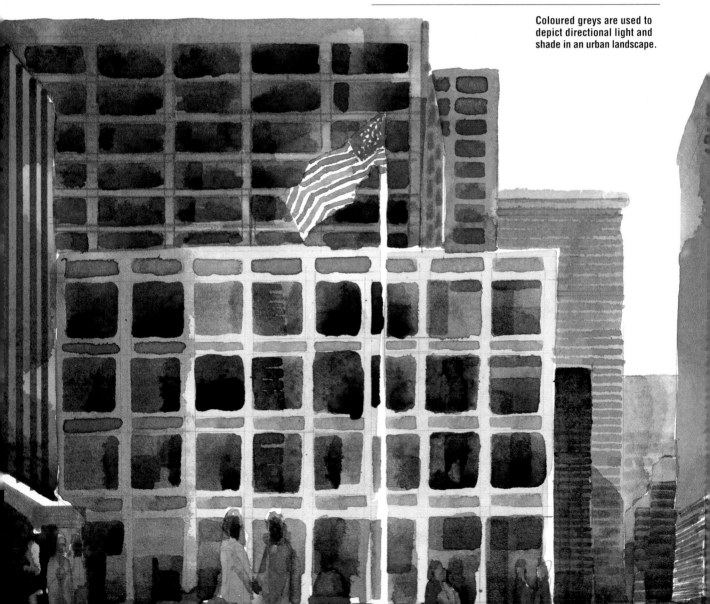

THE COLOURS

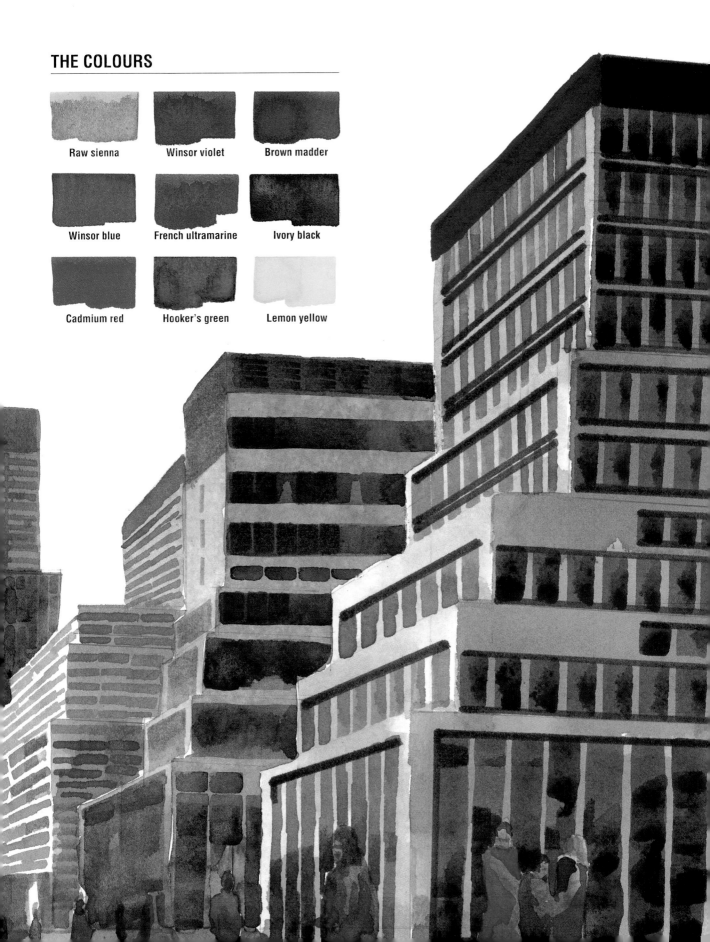

Raw sienna

Winsor violet

Brown madder

Winsor blue

French ultramarine

Ivory black

Cadmium red

Hooker's green

Lemon yellow

ARCHITECTURE/2

Ochres, pinks and browns are the colours of the Mediterranean, particularly of southern France and Italy. Earth pigments used for painting houses and churches are often quarried locally, and the same earthy colours can be seen in the nearby hills and fields.

Umbers, siennas and ochres – colours used by artists all over the world – still come mainly from Italy. It is little wonder, therefore, that the colours and architecture of the Mediterranean have always been so attractive to the artist.

Mediterranean light produces stark contrasts, creating bright colours as well as dark shadows. Paint and stucco on old buildings may be shabby or faded, but in the bright sunshine the painted colours glow as brightly as the fresh pigments which went into them. The warm oranges and salmon pinks in this ancient Italian marketplace are as much the result of light as local colour. Contrasting shadows are deep blues and purples. A similar scene in northern Europe would be dull and grey by comparison.

THE COLOURS

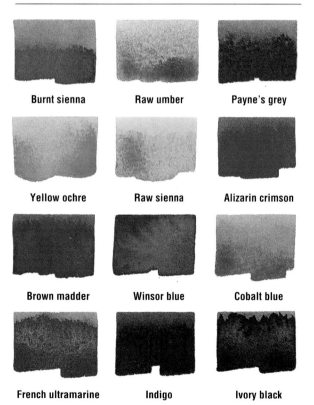

Burnt sienna	Raw umber	Payne's grey
Yellow ochre	Raw sienna	Alizarin crimson
Brown madder	Winsor blue	Cobalt blue
French ultramarine	Indigo	Ivory black

THE PIAZZA

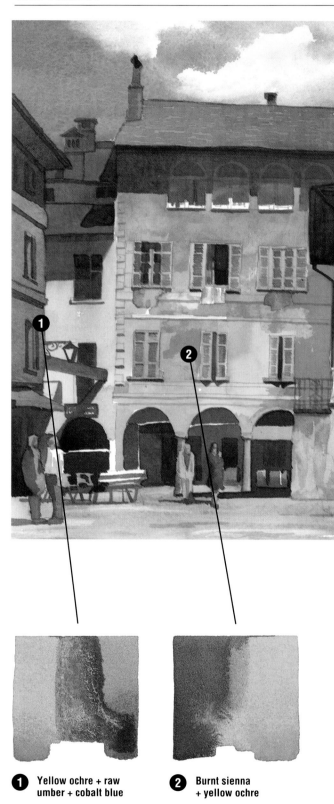

1 Yellow ochre + raw umber + cobalt blue

2 Burnt sienna + yellow ochre

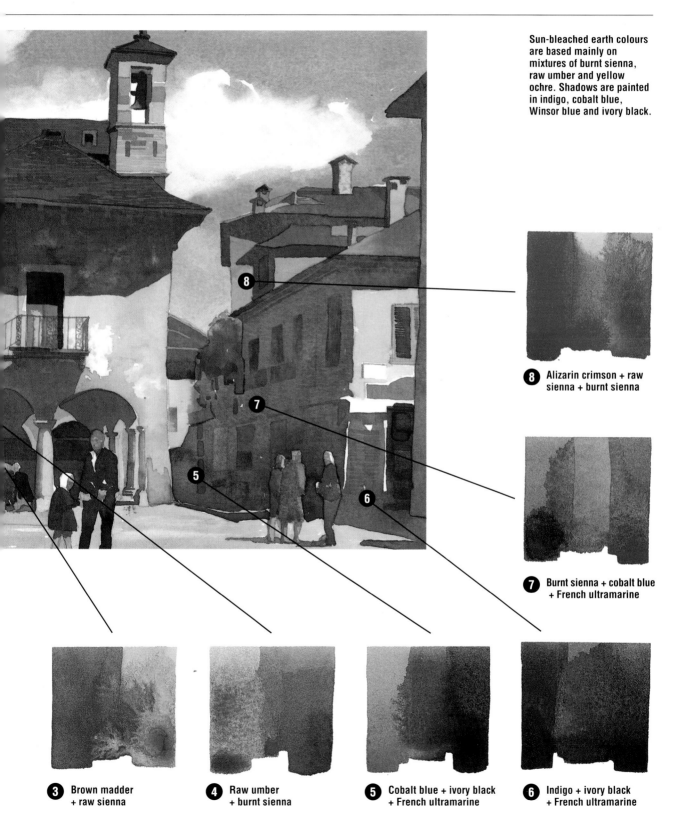

Sun-bleached earth colours are based mainly on mixtures of burnt sienna, raw umber and yellow ochre. Shadows are painted in indigo, cobalt blue, Winsor blue and ivory black.

8 Alizarin crimson + raw sienna + burnt sienna

7 Burnt sienna + cobalt blue + French ultramarine

3 Brown madder + raw sienna

4 Raw umber + burnt sienna

5 Cobalt blue + ivory black + French ultramarine

6 Indigo + ivory black + French ultramarine

105

CLOUDY SKIES

Clouds are colourful. They are rarely simply white or grey. In winter, for instance, clouds are often seen against cold sunlight, which filters through and illuminates the edges of cloud formations with a pale yellow. As a general rule, the yellow should not be too strong. Aureolin or yellow ochre are often better than a bright yellow.

Leaden skies look grey, but this is not the result of mixing black with white. It comes from other sources which may include traces of purple, green, orange. This effect can often be captured using just two colours. For example, the thundery clouds illustrated here were portrayed with loose strokes of Payne's grey and yellow ochre, with added touches of cerulean blue and Winsor violet.

Changing skies

Clouds move rapidly, and painting on the spot means working quickly. But you can lay a general sky colour in broad washes, and then lift the paint with a brush or sponge to create pale cloud areas. Some blues, such as Winsor and Prussian blue, stain the paper instantly, making them difficult to lift. Others, like cobalt blue and French ultramarine, are slightly granular and have a weaker staining capacity. Thus many artists find these colours are particularly suitable for painting skies and clouds.

Another approach is to leave cloudy areas unpainted from the outset. Hard edges can be softened with water, or use diluted Payne's grey to give a shadow effect along the edges of the clouds.

THE COLOURS

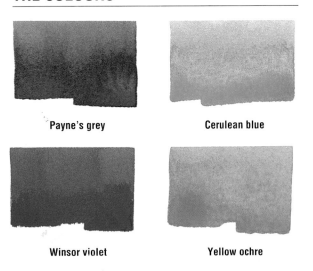

Payne's grey

Cerulean blue

Winsor violet

Yellow ochre

HEAVY SKIES

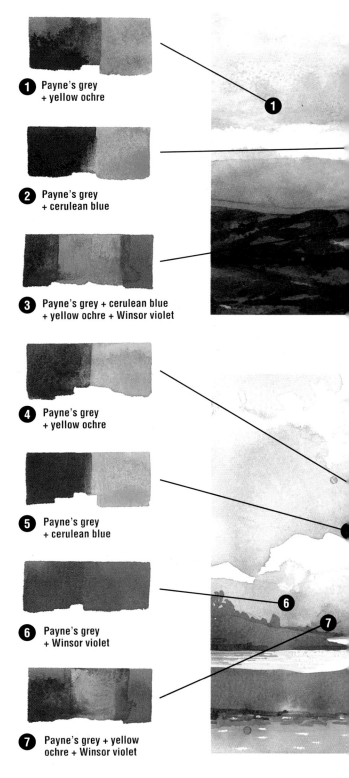

1 Payne's grey + yellow ochre

2 Payne's grey + cerulean blue

3 Payne's grey + cerulean blue + yellow ochre + Winsor violet

4 Payne's grey + yellow ochre

5 Payne's grey + cerulean blue

6 Payne's grey + Winsor violet

7 Payne's grey + yellow ochre + Winsor violet

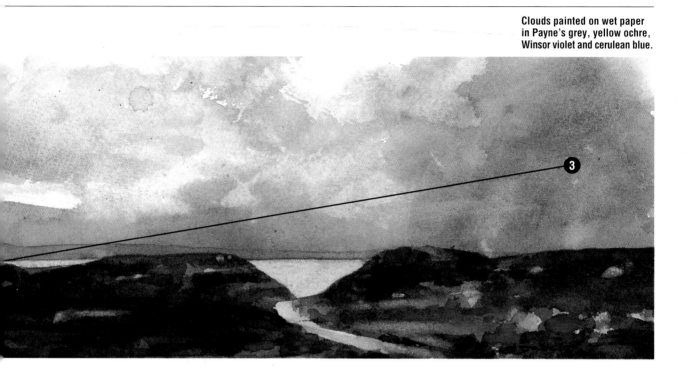

Clouds painted on wet paper in Payne's grey, yellow ochre, Winsor violet and cerulean blue.

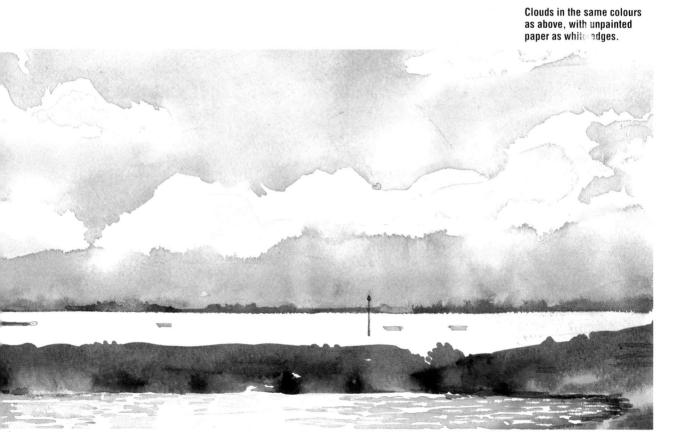

Clouds in the same colours as above, with unpainted paper as white edges.

BRIGHT SKIES

When painting skies in any medium, there is a definite distinction between 'whiteness' and 'lightness'. With watercolour, however, this presents no problem because the lightness of the paper shows through the naturally transparent paint. This creates a far better impression of light and infinite space than the introduction of white paint, which tends to create flat, solid colour.

A clear blue sky is not an area of even colour, but a graduated expanse which often becomes paler towards the horizon. The impression here is one of colour as well as light. Graded watercolour, ranging from dense colour to a barely visible wash, is the perfect technique for capturing this effect.

As the sky becomes lighter, it can also change colour: a bright cobalt sky may gradually turn into pale cerulean as it gets close to the horizon.

Sunlight

On a bright day, light from the sun naturally affects a large proportion of the sky. The sun itself has a colour – a visible yellow or orange – but light radiating from the sun has a far-reaching effect and appears to lighten and whiten the surrounding areas. Again, this can be captured effectively with graded washes, which become increasingly pale and watery as they move towards the bleached area surrounding the sun.

Sunrises and sunsets are much more colourful, yet a limited palette can be surprisingly effective in achieving the dramatic displays of the sun in evening and early morning. The same palette was used for both the paintings shown here, but in the lower picture the colours are stronger.

THE COLOURS

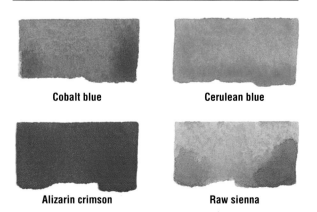

Cobalt blue

Cerulean blue

Alizarin crimson

Raw sienna

BLUE SKY AND SUN

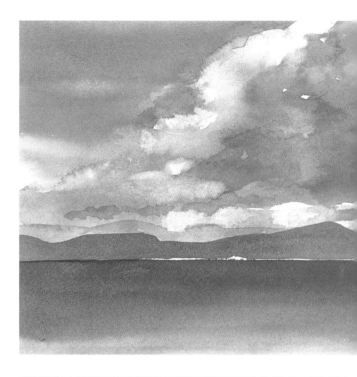

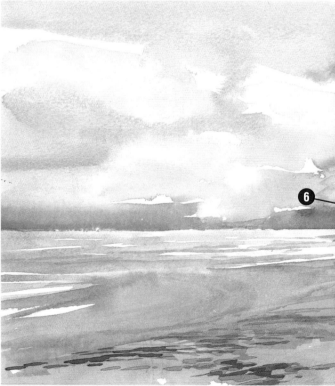

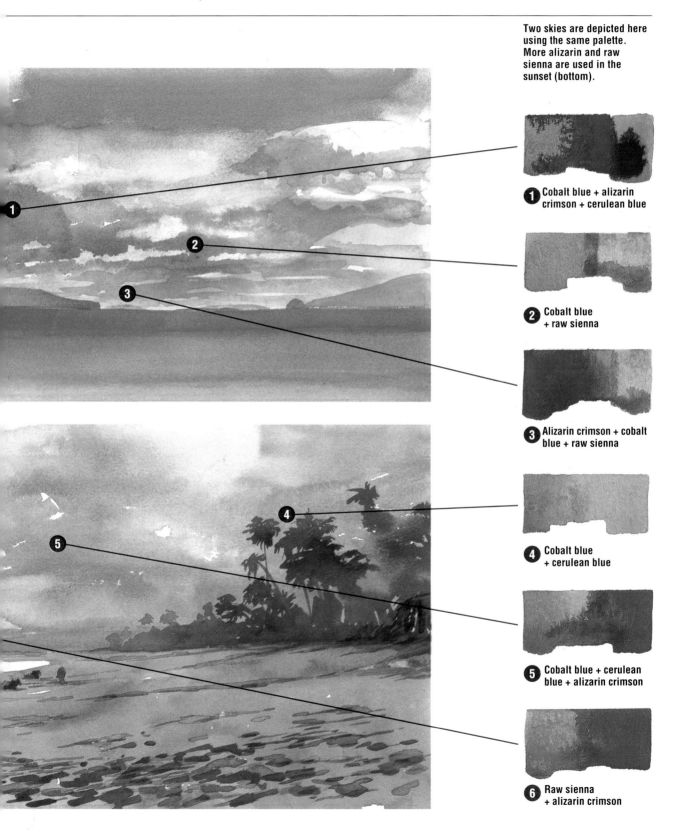

Two skies are depicted here using the same palette. More alizarin and raw sienna are used in the sunset (bottom).

1 Cobalt blue + alizarin crimson + cerulean blue

2 Cobalt blue + raw sienna

3 Alizarin crimson + cobalt blue + raw sienna

4 Cobalt blue + cerulean blue

5 Cobalt blue + cerulean blue + alizarin crimson

6 Raw sienna + alizarin crimson

EARLY EVENING

Without light there is no colour, and the strength and type of any light affects our perception of all the colours around us. Natural daylight is usually colder than most electric lighting, and a painting begun by day cannot easily be continued by artificial lighting because the colours in both the picture and the subject look very different. This is why all painting should be done in a constant, unchanging light.

Daylight varies according to season, climate and time of day. Early one late-summer evening after a moorland picnic, this watercolour sketch was painted quickly, on the spot, using broad brush strokes to catch the rapidly changing light.

Systematic colour

To save time, the artist worked systematically, dividing the painted landscape into four distinct areas of colour – the sky, the distant hills, the middle distance and the foreground.

The cobalt blue sky was brushed onto wet paper with a large brush and very diluted paint. This was allowed to dry unevenly, before adding the distant hills in washes of indigo, cobalt blue and touches of sepia. The nearer hills and pale green fields were then established with broad strokes of slightly stronger colour – light yellowish green for the fields, and mixtures of indigo and blue for the hills.

The artist began the foreground with an uneven wash of gamboge. Trees, grass and shadows were painted over the yellow, with some areas being left to show through as patches of sunlight. Then the warm sunlight was taken into the middle distance with washes of gamboge and Venetian red.

THE COLOURS

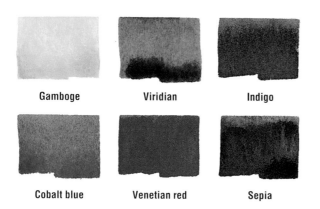

| Gamboge | Viridian | Indigo |
| Cobalt blue | Venetian red | Sepia |

UPPER BOOTH

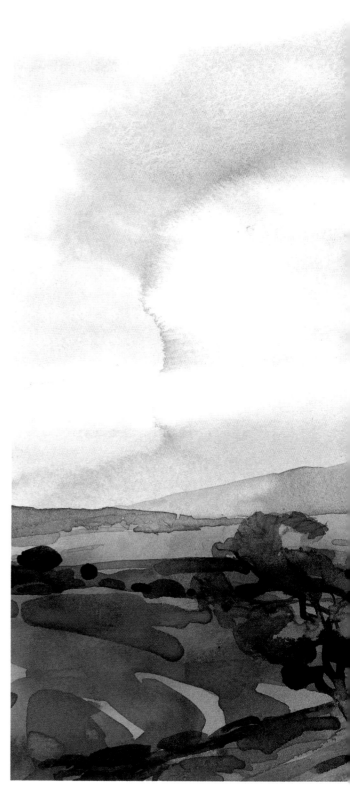

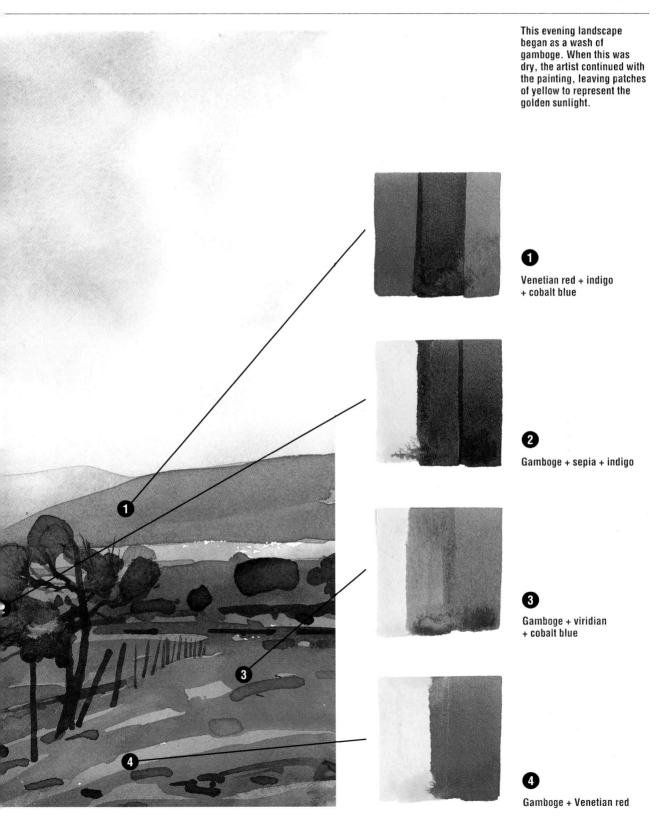

This evening landscape began as a wash of gamboge. When this was dry, the artist continued with the painting, leaving patches of yellow to represent the golden sunlight.

1 Venetian red + indigo + cobalt blue

2 Gamboge + sepia + indigo

3 Gamboge + viridian + cobalt blue

4 Gamboge + Venetian red

111

CONTRE JOUR

When the light is directly behind a subject, the artist sees only the shaded side of what is being painted – sometimes referred to as working 'contre jour', or against the light. Sometimes the subject is visible only as a silhouette.

Contre jour is traditionally used in landscapes, particularly early-morning and evening scenes, when the sun provides a colourful and often romantic backdrop to the darker foreground shapes. A figure or still-life arrangement placed against a bright window produces a partial contre jour effect. However, the artist must have enough indoor light by which to paint, and this means that a certain amount of front light falls on the subject.

For contre jour, the emphasis is on tone – the relationship between the lights and darks – rather than colour. It does not mean a complete absence of colour; nor does it imply that the darkest tones must be black. The contre jour opposite contains very little black: the artist used the same number of colours as for the daylight painting below.

Warm reds and oranges in the sky create complementary colours in the shadows. The silhouetted palms contain traces of green and blue.

TROPICAL PALMS

Painting by day, the artist was able to see all the local colours of the trees and foliage against the light blue sky.

THE COLOURS

Cerulean blue

Payne's grey

Raw sienna

Cobalt blue

Hooker's green

Cadmium yellow

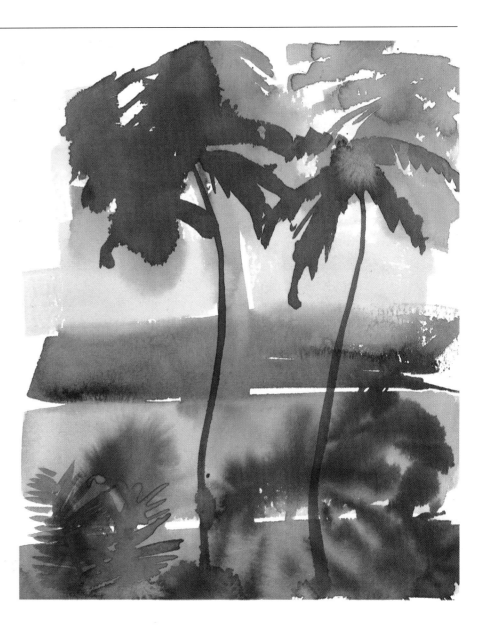

AGAINST THE LIGHT

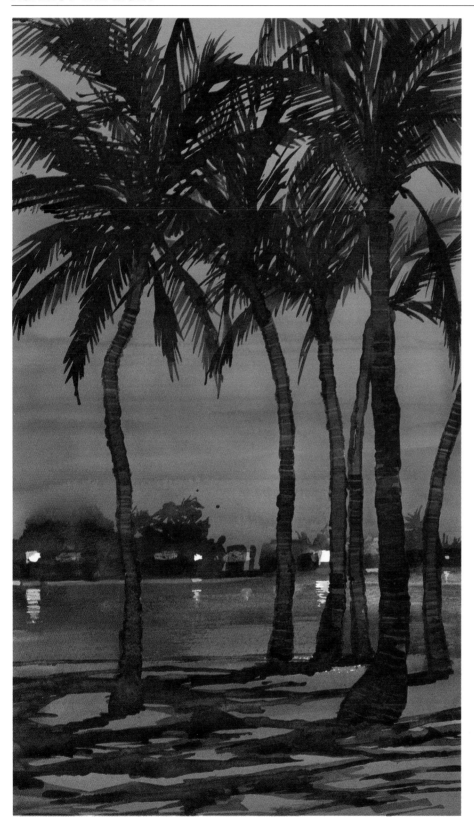

At night, when the sun is setting behind the palms, only the dark shapes of the trees are visible against the fading light.

THE COLOURS

Cadmium orange

Alizarin crimson

Raw sienna

French ultramarine

Ivory black

Winsor blue

WHITE LIGHT

Light is transparent, and the less colour you use, the brighter the painted light will appear to be. The strongest light is achieved by using no colour at all, but simply leaving areas of unpainted white paper.

To create this effect, it is important to work out in advance exactly where the white areas will be – a sort of thinking 'in reverse' is required. If areas intended to be white get painted accidentally, this is not easily rectified. White paint is certainly not the answer because of its opacity, which will spoil the desired effect of transparent light.

Dappled light

For this painting, the artist started with an outline sketch, indicating all areas to be left white. These areas were protected with masking fluid before any colour was applied. The white light on the grass and trees is delicate and dappled – an effect which was achieved by applying the masking fluid with a small piece of synthetic sponge, cut and torn to create a textured surface. Alternative dappled textures can be created using wax resist.

The subject is predominantly green, but there is no green on the palette. All greens in the painting are mixtures of lemon yellow, cadmium yellow, Winsor blue, French ultramarine and Payne's grey. Combinations of these colours allowed the artist to emphasize the gradations of light and shade, ranging from pale lemon to dark blue-grey, rather than the local colour of the green foliage.

Between the far trees, distant foliage is painted in pale, hazy blue – a diluted wash of Winsor blue with touches of cadmium yellow and Payne's grey.

THE COLOURS

Burnt sienna

Payne's grey

French ultramarine

Winsor blue

Cadmium yellow

Lemon yellow

BASLOW WOODS

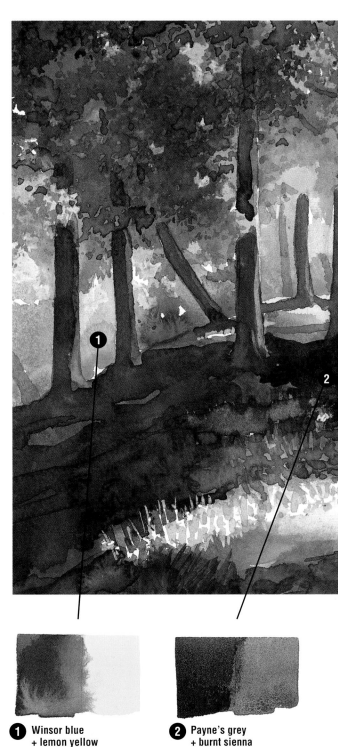

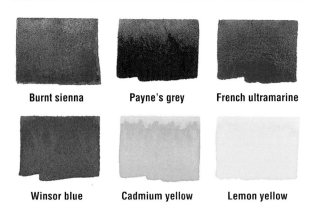

1 Winsor blue + lemon yellow

2 Payne's grey + burnt sienna

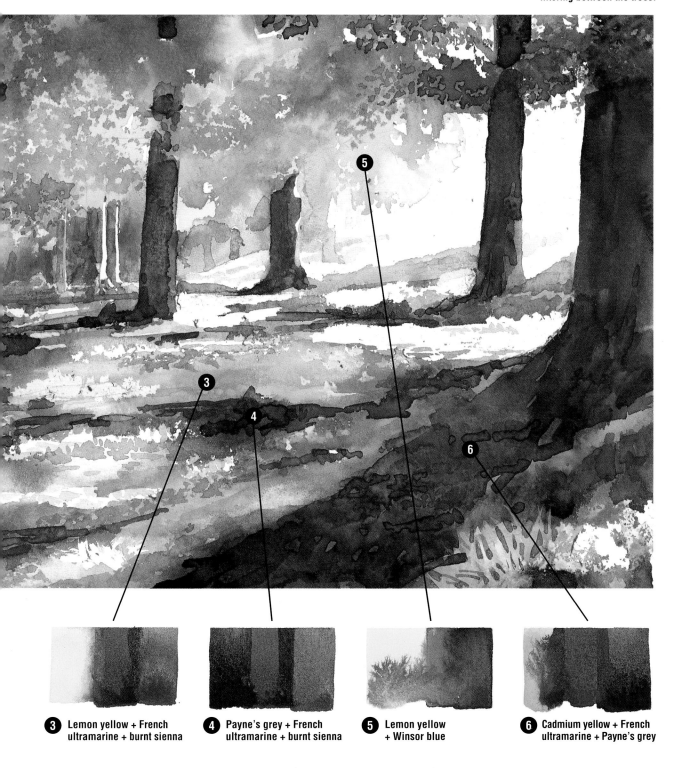

Masking fluid created the effect of white sunlight filtering between the trees.

3 Lemon yellow + French ultramarine + burnt sienna

4 Payne's grey + French ultramarine + burnt sienna

5 Lemon yellow + Winsor blue

6 Cadmium yellow + French ultramarine + Payne's grey

115

COLOUR AROUND US

A PALETTE FOR SPRING

Ｎew foliage can be astonishingly varied and bright, containing a range of yellows from warm, golden tones to cool, acidic lemons. There were 12 colours on the palette for this on-the-spot landscape painting. The artist has frequently painted similar scenes using fewer colours. However, the quality of light on this particular spring day was so stunning, and the resulting colours so varied, that he decided to use a wider than normal palette. His final selection includes a range of yellows, blues and greens suitable for mixing the fresh greens of springtime.

Spring yellows

Three yellows were used – lemon, cadmium and aureolin. Mixed with green and blue, they produced most of the foliage and grass colours. The comparatively cool spring sunlight on the trees and fields in the middle distance is created from mixtures of lemon and aureolin with added touches of blue and green. Masking fluid was used for the crisp white narcissi shapes in the foreground.

THE COLOURS

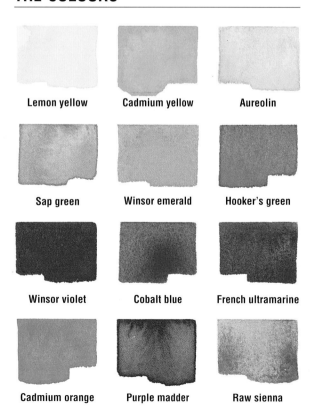

Lemon yellow	Cadmium yellow	Aureolin
Sap green	Winsor emerald	Hooker's green
Winsor violet	Cobalt blue	French ultramarine
Cadmium orange	Purple madder	Raw sienna

FROM MAYFIELD HILL

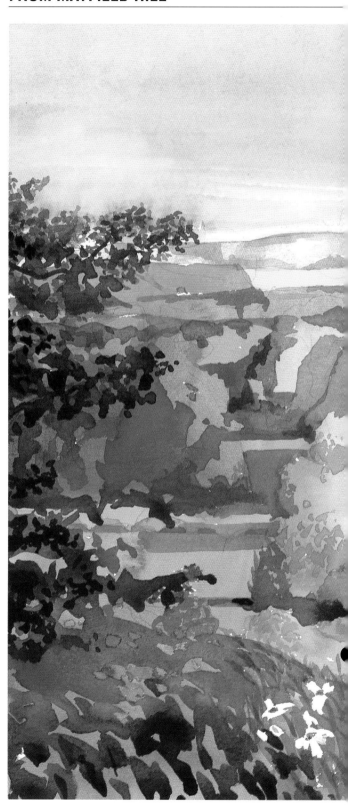

116

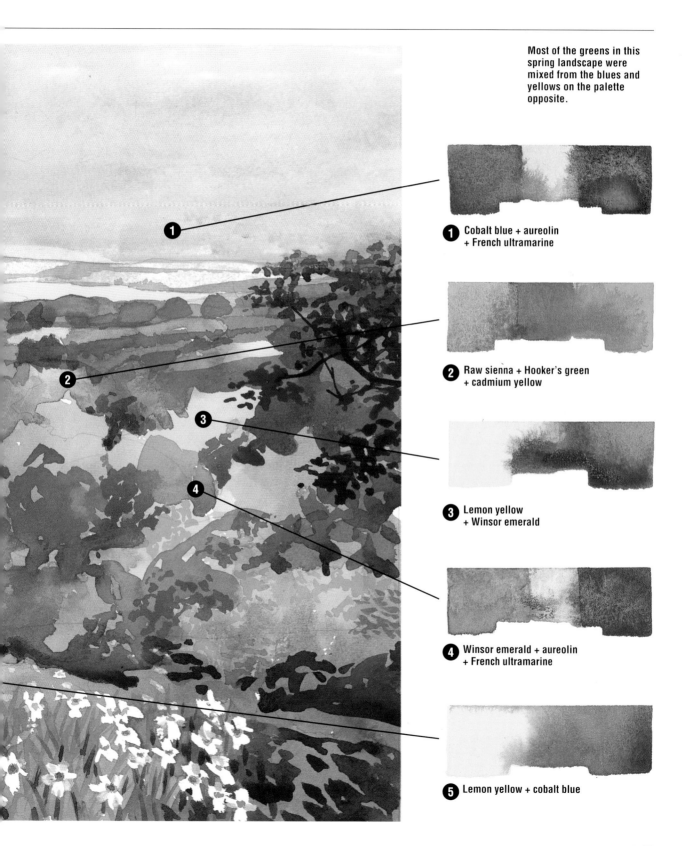

Most of the greens in this spring landscape were mixed from the blues and yellows on the palette opposite.

1 Cobalt blue + aureolin
+ French ultramarine

2 Raw sienna + Hooker's green
+ cadmium yellow

3 Lemon yellow
+ Winsor emerald

4 Winsor emerald + aureolin
+ French ultramarine

5 Lemon yellow + cobalt blue

A PALETTE FOR SUMMER

This Italian courtyard – decorated in glistening white and brilliant blue, and full of red and pink geraniums – is captured in watercolour only by using the brightest and most saturated colours on the artist's palette. Even the shadows, darkened by the intensity of strong sunlight, are full of luminous colour.

Sun and shadow

For the bright whiteness of the courtyard walls, areas of white paper are left unpainted. Shadows on the white walls are mixed mainly from cerulean blue and Winsor violet, with added Payne's grey for the darker tones. The paintwork and flower pots are Winsor blue and French ultramarine, with paler, diluted colour on the sunlit areas.

The view framed by the open doorway forms a miniature Umbrian landscape. Outside, colours are earthy and sombre compared with the blues and reds of the enclosed courtyard. The strong sun causes these earth colours to appear pale and bleached, creating contrasting stark shadows.

THE COLOURS

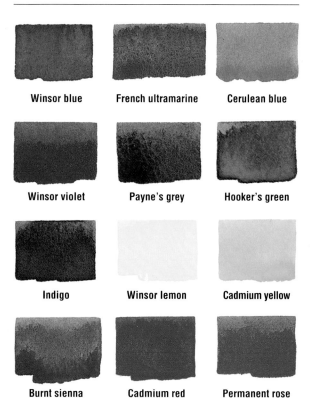

Winsor blue French ultramarine Cerulean blue

Winsor violet Payne's grey Hooker's green

Indigo Winsor lemon Cadmium yellow

Burnt sienna Cadmium red Permanent rose

COURTYARD IN UMBRIA

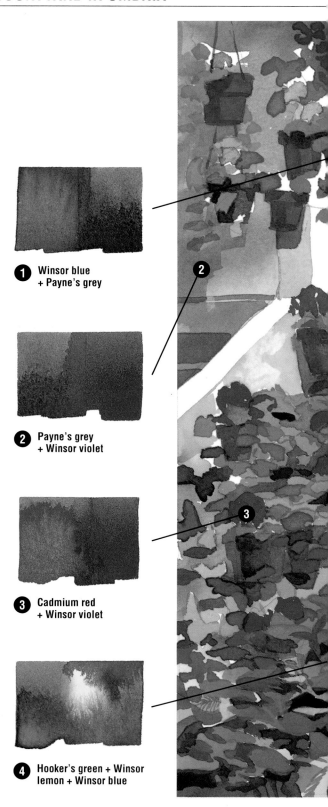

1 Winsor blue + Payne's grey

2 Payne's grey + Winsor violet

3 Cadmium red + Winsor violet

4 Hooker's green + Winsor lemon + Winsor blue

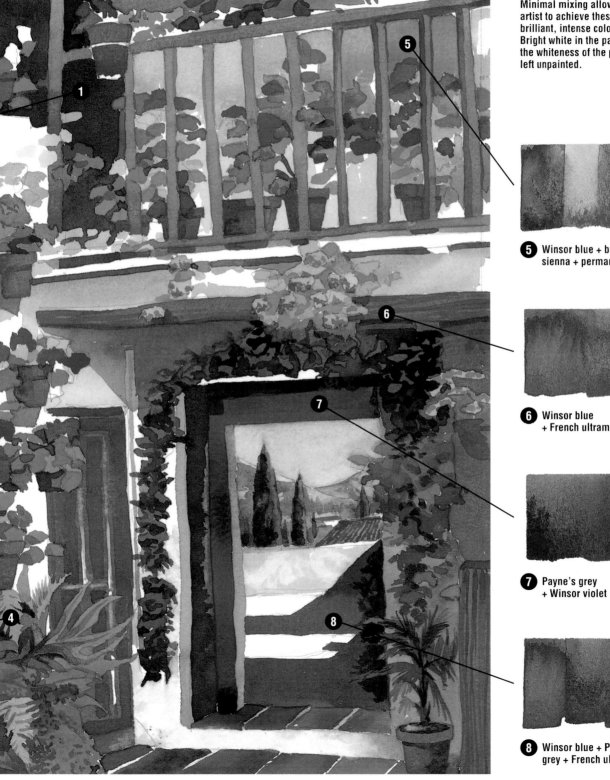

Minimal mixing allowed the artist to achieve these brilliant, intense colours. Bright white in the painting is the whiteness of the paper, left unpainted.

5 Winsor blue + burnt sienna + permanent rose

6 Winsor blue + French ultramarine

7 Payne's grey + Winsor violet

8 Winsor blue + Payne's grey + French ultramarine

A PALETTE FOR AUTUMN

The colours of autumn are not just the warm reds, ambers and ochres. There are cool colours too, in the shadows, in the sky and in the green foliage still present in the autumn landscape. It is the contrast with these cool colours which brings out the warmth of a typical autumn.

For instance, the fresh green can be mixed by using lemon yellow – a sharp, cool yellow – to contrast with the earthy colours more usually associated with this season. You will also need cool colours to tone down the local colours.

Autumn is not necessarily the picture-book scene that immediately springs to mind. Greys and dead-looking browns can be seen, especially in late autumn when some of the trees are almost bare. A good way of choosing your palette is to pick up a

handful of leaves. Examine these for an indication of the colour scheme of the finished painting. Not all the leaves turn to picturesque red and orange.

Autumnal colour

The most vivid orange in the painting is mixed from lemon yellow and Winsor red; the blue between the trees is a mixture of indigo and cobalt. These two colours, opposites on the colour wheel, represent the brightest areas in the picture and are the basis for most of the other colour mixtures.

When the artist wants to tone down the bright orange – as for the large central tree – this is done by diluting the orange and adding a little of the blue mixture. To tone down the blue, as in the foreground, water and a little of the orange is

AN AUTUMN LANDSCAPE

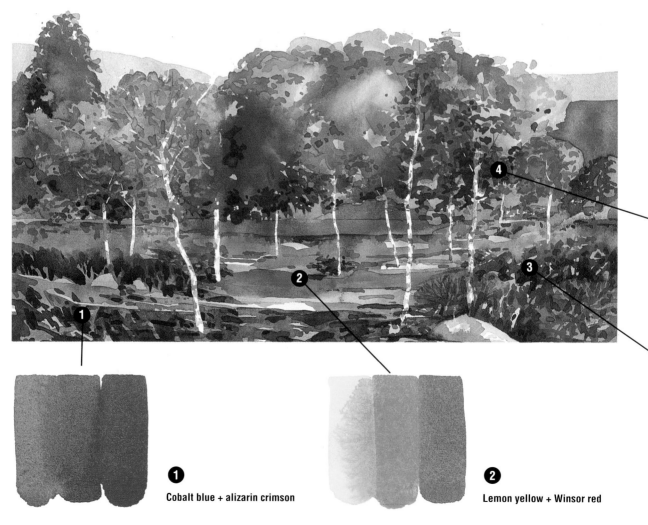

1 Cobalt blue + alizarin crimson

2 Lemon yellow + Winsor red

THE COLOURS

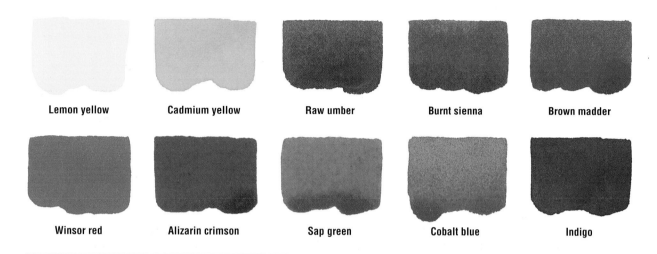

Lemon yellow	**Cadmium yellow**	**Raw umber**	**Burnt sienna**	**Brown madder**

Winsor red	**Alizarin crimson**	**Sap green**	**Cobalt blue**	**Indigo**

added. In this way, the painting achieves an overall colour harmony without diminishing or cancelling out the effect of the brightest colours.

Painting a landscape

The woodland scene was painted on a sunny autumn day when the colours were at their best. The artist made a selection of colours from the general palette but also made a few additions. Brown madder is one – a rich reddish brown which was prevalent in the scene. In another change,

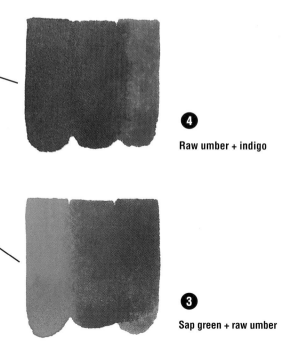

4

Raw umber + indigo

3

Sap green + raw umber

Winsor red replaced cadmium red, to reproduce rich reds and oranges. The colours here are very simple. There is little detail to break up the loose areas of colour, so each stands out.

The most important colours are the vibrant oranges of the trees and leaves. The brightest of these was mixed from Winsor red and lemon yellow. But it is not strength of colour alone which makes this painting so striking. Without the blues and purples in the shadows and background, the orange would be far less effective.

Touches of sap green, brown madder and burnt sienna are used for the local colour of the grass and shrubby undergrowth in the foreground. The dark detail on the trees appears black, but is actually a mixture of raw umber and indigo. There is no black in the painting.

The warm autumn foliage stands out because of the contrasting cool colours. In fact, the cool colours went down first: the artist's initial task was to apply a cool washy background, some of which shows through in the finished painting – in the sky, the silvery colour of the tree trunks and as dappled patches of light on the ground.

The painting then progressed from light to dark, starting with the pale, cool colours, and gradually working up to the brightest reds and oranges, which are what the painting is all about. The same subject painted entirely in warm colours, without the cool contrast, would lack the resonance and brilliance captured here. In this painting, the oranges leap forward because of the contrasting deep blues and purples between the trees.

121

A PALETTE FOR WINTER

Weather dictates the colours of winter, from monochromatic greys to a spectrum of blinding brilliance. The brightest scenario of all is the dramatic sight of newly fallen snow on a clear day, when the glistening white reflects surrounding colours, including those of the sun and sky.

The downside of this uplifting scene is the inevitable cold, which makes painting outdoors uncomfortable and slow. Fingerless gloves are effective for only a few minutes, and low temperatures also affect the drying time of paint, making the whole process even slower.

This frosty scene was painted from an upstairs window, by an artist with an injured ankle who was barred from any more skiing! A less painful alternative is to make sketches and take colour photographs, and then do the painting at home.

Coloured shadows

Shadows on snow are surprisingly colourful, often reflecting the colour of the sky, which here is clear blue. Similarly, bright sunshine gives snow a glowing golden appearance which can turn to pinks, violets and oranges at sunrise and sunset.

Snow also creates extreme tonal contrasts. By looking carefully at the subject before starting to paint, the artist simplified the tones. The lightest tone is the white of the snow; the darkest, the fir trees. All other tones have been cut to three shades of blue – pale, medium and dark. The simplified shapes allowed the use of broad brush strokes and the elimination of much superfluous detail.

Touches of Chinese white are used for the snow on the fir trees. Otherwise, the mass of snow is depicted by the whiteness of the paper.

THE COLOURS

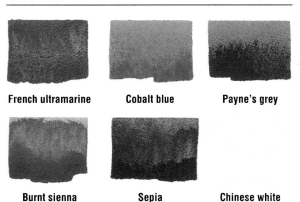

French ultramarine **Cobalt blue** **Payne's grey**

Burnt sienna **Sepia** **Chinese white**

LE MONT D'OR

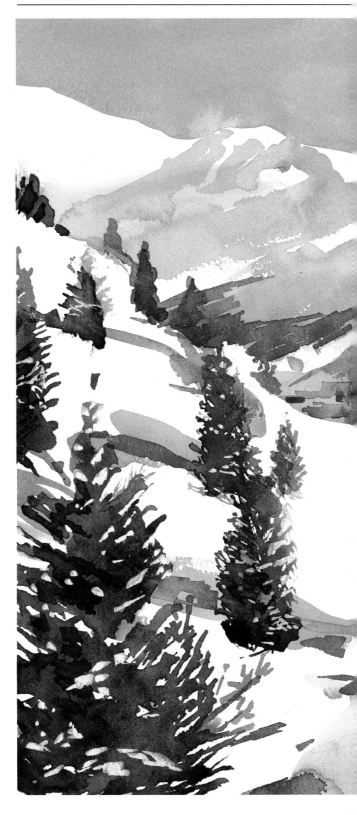

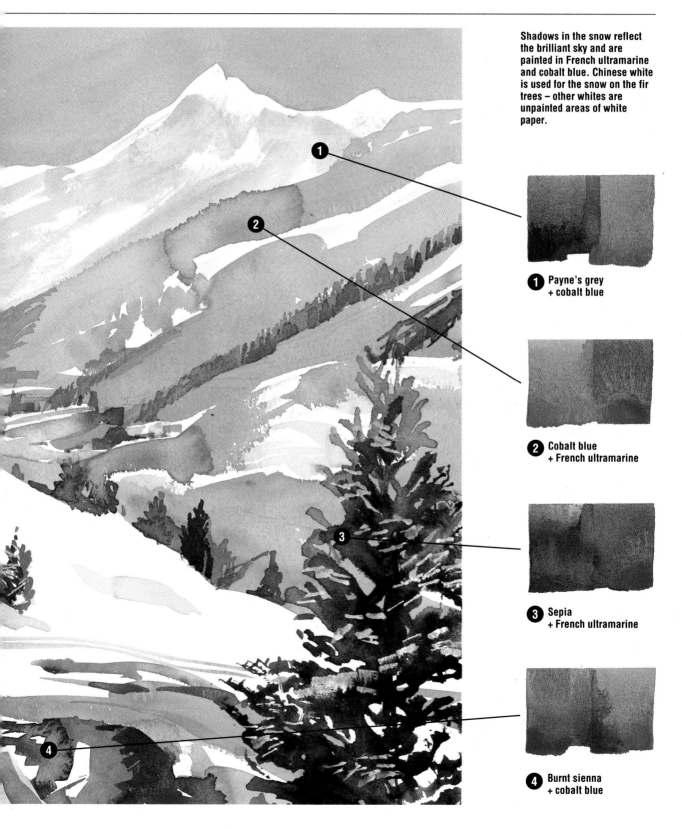

Shadows in the snow reflect the brilliant sky and are painted in French ultramarine and cobalt blue. Chinese white is used for the snow on the fir trees – other whites are unpainted areas of white paper.

1 Payne's grey + cobalt blue

2 Cobalt blue + French ultramarine

3 Sepia + French ultramarine

4 Burnt sienna + cobalt blue

GLOSSARY

ADDITIVE PRIMARIES Also known as the 'light' primaries, green, red and blue are the additive primaries. When projected in equal quantities they create white light.

ADVANCING COLOURS Hot or bright colours which stand out and appear to advance or come forward from the picture.

ANALOGOUS HARMONY Colours which are in the same section of the colour wheel and which have a primary colour in common. For example, red, red-orange and orange create an analogous harmony.

ATMOSPHERIC PERSPECTIVE A means of creating space in a painting by using cool or pale colours which appear to recede into distance. Also known as aerial perspective.

BINDER Substance used to bind pigment and other ingredients in the manufacture of paint. Watercolour binder is usually gum arabic, or a similar solution.

BODY COLOUR Watercolour mixed with white to make it opaque. Gouache is a form of commercially prepared body colour.

CHIAROSCURO Extreme tonal contrast usually created by strong directional light causing correspondingly dark shadows.

CHINESE WHITE Watercolour white which contains chalk and is opaque, although the paint particles are finer than those in opaque gouache.

COLOUR HARMONY Colours which 'go together' are described as harmonious. These include colours which lie in the same section of the colour wheel and have a primary colour in common. They also include colour mixtures which have a colour in common.

COLOUR TEMPERATURE Warm colours are red, orange and yellow; cool colours are green and blue. In addition, there are warm and cool versions of individual colours. For example, alizarin crimson is a cool red; cadmium red is comparatively warm. Similarly, lemon yellow is cooler than cadmium yellow.

COLOUR WHEEL A circular diagram used to demonstrate colour relationships and properties in a graphic way.

COMPLEMENTARY COLOURS Pairs of colours found on opposite sides of the colour wheel. Complementary pairs are red and green; yellow and violet; and blue and orange. Seen next to each other, complementary colours are mutually enhancing.

COMPOSITION The design of a painting – the arrangement of various elements, including shapes, tones, textures and colours.

EARTH COLOURS Colours manufactured from naturally occurring minerals, clays and silicates.

FRESCO A painting technique in which colour is applied to wet plaster. Fresco painting has been practised in Italy since the 13th century.

FUGITIVE COLOURS Dyes or pigments which are not permanent.

GLAZING Using a transparent layer of colour over another colour.

GOUACHE An opaque form of watercolour. See BODY COLOUR.

GRADED WASH A wash which is graded from light to dark, or is laid in two or more colours.

GUM ARABIC A natural gum obtained from the sap of certain acacia trees. It is watersoluble, and used as a binder in watercolour paints.

LAKE COLOURS Colours manufactured from pigments made by suspending a dye in a colourless base substance.

LIFTING COLOUR The process of removing wet colour with a dry brush, tissue, sponge or cloth to reveal the white paper or underlying colour.

LIGHT TO DARK A technique which involves painting dark tones over pale or diluted colours. The approach is almost essential with watercolours because the paints are transparent, making it virtually impossible to lay light colours over darker ones.

LOCAL COLOUR The colour of an object, unaffected by light, shade, atmosphere or reflections.

MASKING Protecting an area of paper or an area of colour before another colour is applied. See MASKING FLUID.

MASKING FLUID A liquid rubber solution which can be applied to selected areas of the paper or painting. Paint can be applied over the dried masking fluid, which is eventually removed by rubbing with an eraser or finger.

MEDIUM The term has two distinct meanings. It refers to the type of materials used by the artist, such as watercolour, oils, soft pastel, etc. Alternatively, it is used to describe the various substances and additives which can be mixed with the paint in order to change or modify its effect.

MONOCHROME Painting done in tones of one colour. With watercolour, the white paper is used to create the lightest tones.

NEUTRAL Strictly speaking, this is the 'non-colour' which results when equal quantities of the primary colours are mixed together. However, the term is more

usually used to describe muted colours, and colours which have been modified by adding quantities of a complementary colour.

OPAQUE Not transparent. When applied to paint it means the ability of a colour to hide or obliterate an underlying colour.

OPPOSITE COLOURS see COMPLEMENTARY COLOURS.

OPTICAL MIXING Mixing colour in the painting rather than on the palette. Two or more colours are applied in small dots or patches so that when seen from a distance they form another colour.

PALETTE The term has two meanings. It is used to describe the board or dish on which the paint is mixed. It also describes the range of colours used by the artist.

PICTURE PLANE An imaginary, vertical plane which defines the front edge of the illusionary space in a painting.

PIGMENT A coloured substance which can be combined with a binder to produce painting and drawing materials.

PLANE A surface area of a three-dimensional object.

POINTILLISM A painting technique involving the optical mixing of colour. For example, an area of orange might be built up largely with tiny dots or patches of yellow and red.

PRELIMINARY SKETCH A rough sketch made by the artist prior to starting a finished work. Preliminary sketches are used to help establish the composition, colours, tones, format and other aspects of the final work.

PURE COLOUR The primary colours, and any mixtures of the primary colours, are described as 'pure'.

RECEDING COLOURS Cool or pale colours which tend to diminish or recede in the picture. Pale blues and greens are typically recessive colours which are used to denote distance in landscape painting.

RENAISSANCE The period of development in Italian art and culture from the 14th to the early 16th century.

RESIST A technique involving two incompatible materials. For example, wax crayon or candle marks will repel subsequent applications of watercolour to produce a characteristic textured effect.

SATURATED COLOUR Colour at its strongest and most intense.

SCALPEL Sharp cutting knife with a removable blade.

SECONDARY COLOURS These are green, orange and violet – the three colours created by mixing the three pairs of complementary primaries. Red and yellow make orange; blue and yellow make green; and blue and red make violet.

SGRAFFITO Scratching areas of dry colour with a scalpel or other sharp instrument in order to reveal the white paper underneath. The technique is used for creating lines or texture in watercolour paintings.

SPATTERING Mottled or granular textures created by flicking colour on to the paper from a loaded, stiff brush. This can be done with a short, flicking movement, or by drawing a finger across the bristles to disperse the paint.

SPONGING Applying paint with a natural or synthetic sponge to create areas of texture and broken colour.

STAINING CAPACITY see TINTING CAPACITY.

SUBTRACTIVE PRIMARIES Also known as 'artists' primaries, the subtractive primaries are red, yellow and blue. When mixed in equal quantities they create a dark neutral which appears almost black.

TEMPERA Paints made from pigment and an emulsion of oil and water.

TERTIARY COLOURS A colour mixed from a primary and secondary colour is known as a tertiary colour. There are six tertiaries: blue-green, blue-violet, red-orange, red-violet, yellow-orange and yellow-green.

TINTING CAPACITY The capacity of a colour to stain the paper or affect other colours in mixtures.

TONAL CONTRAST Term used to describe the relationship of lights and darks in a painting.

TONAL SCALE Every colour has a tone – an equivalent grey on a tonal scale which ranges from nearly white to nearly black.

TONE The light or dark value of a colour.

TONED PAPER Paper which has a tone or tint instead of being pure white. Toned paper affects the colour of transparent watercolours, which are usually mixed with Chinese white or gouache to make them more opaque.

WASH Diluted watercolour applied thinly to the paper. Washes are normally used to create areas of even, transparent colour during the early stages of a painting.

WATERCOLOUR Watersoluble artists' paint made from pigment mixed with a binder, such as gum arabic. Unlike most paints, watercolour is transparent and is most effective when applied by laying the lightest tones first.

WET IN WET Colour applied to a paper which is already wet with paint or water.

WET ON DRY Paint applied to dry paper or colour.

ACKNOWLEDGEMENTS

The author would like to thank Freya Dangerfield, Brenda Morrison and Kate Yeates at David & Charles; Ian Howes for studio photographs; Joe Short for design and layouts; Adrian Smith for illustrations, paintings and colour mixtures; and all the other artists who have contributed to this book. She would also like to thank Winsor and Newton for their generous help with materials and colours, especially Tania Kingston for her invaluable interest and assistance.

PICTURE CREDITS

INDEX